$50

P9-DTT-618

$50

Surrational Images

Surrational Images

Photomontages by Scott Mutter

Foreword by Martin Krause

University of Illinois Press

Urbana and Chicago

© 1992 by Scott Mutter
Manufactured in the United States of America
C 5 4 3 2 1

This book is printed on acid-free paper.

Library of Congress Cataloging-in-Publication Data
appear at the end of this volume

To my parents, and to my niece Erin Mutter

Foreword

"The camera doesn't lie"—it's an automatic reflex. We consign to photography our highest moments, trusting that the photograph will preserve the details better than we ever could. Like a third eye, the camera obeys the laws of sight without the failings of human memory. At best, a photograph can jog a memory that is fuller than the photograph itself. At worst, the viewfinder is the only eye too many a tourist keeps open. For better or worse, the photograph is our life's preserver—and has been for 150 years.

By and large we take the camera on blind faith. Most of us are irredeemable "poladroids." We believe that what we see through the viewfinder at the moment of the shutter's click will reappear, satisfactorily reproduced, in the photographic print. We do so without a clue as to how the camera works. Its dynamic we leave to the mechanic; its chemistry remains a mystery. "Instamaticians," perforce, believe in insta-magic and are unrepentant. In a concession we make daily, our handiwork is performed by machines of which the camera is one of the most companionable. We're willing to surrender the control if the end product is nevertheless predictably good. The camera has proven itself trustworthy every second of every day of its century and a half. The aggregate of millions of images from millions of viewpoints by millions of practitioners comprises the illustrated encyclopedia of the mundane.

The camera is a machine—industrial rather than industrious. Common sense tells us that it is incapable of prejudice or comment or any other disobedience. We are easily led down the garden path to the assumption that if the camera cannot lie, then a photograph must tell the truth. It is this preconditioned leap of faith that certain photomonteurs like Scott Mutter have always turned to their advantage and on its head.

Photomontage, the art of combining two or more negatives, evolved in the early days of photography. The straight photograph, which told a frail truth, was hemmed in by focal and panchromatic ranges, by shutter and exposure speeds. It could not by itself hold detail equally well in a bright sky and a shadowed foreground. The eye compensates instantaneously for such disparity, and an artist can record such compensation whereas the first photographer could not. The battlelines were drawn between photography and "high art."

Philip Gilbert Hamerton, writing twenty-one years after William Henry Fox Talbot's first photograph of 1839, argued: "photography is not a fine art, but an art science; narrow in range, emphatic in assertion, telling one truth for ten falsehoods, but telling always distinctly the one truth it is able to perceive. . . . its literalness, its mechanical exactitude, and incapacity for selection and emphasis are antagonistic to the artistic spirit."[1] Photomontage, which became possible with the introduction of

1. Philip Gilbert Hamerton, "The Relation between Photography and Painting" (1860), *Thoughts about Art* (Boston: Roberts Brothers, 1874), pp. 54, 65.

glass plate negatives in 1851, could overcome such objections, first technical and then artistic.

Henry Peach Robinson combined five negatives to produce *Fading Away* in 1858. A declining maiden reclining, her grieving parents flanking her in a shadowy interior, and her brooding fiancé staring out a sunlit window are captured in all their respective detail. The composite gives the illusion of optical compensation. While Robinson persistently maintained that combination printing should be reserved for those effects that technically could not be obtained from one plate, it was natural to move from the composite print to compositions—and that was in the realm of art. Once negatives could be combined, the photographer could add or, by masking, subtract elements at will. Unlike a straight photograph, a photomontage could be as aliteral, inexact, and selectively emphatic as any painting Hamerton might wish to example.

In 1857 Oscar Rejlander, who like Robinson had come to photography from a background in painting, ventured into the darkroom with thirty negatives and cooked up his famous allegory *The Two Ways of Life*. Twenty-four separately photographed figures are orchestrated as personifications of "Industry," on the right, and "Dissipation," on the left. Both sentiment and photomontage were to the Victorian taste and popular with Queen Victoria herself. Robinson's and Rejlander's experiments were, however, too carefully timed to the Victorian hour to partake of the timelessness enjoyed by the sweeping second hand of photography.

Both photographers aimed to prove a debatable point: that by intervening in the darkroom between the camera and the object photographed, they could, by human endeavor, compose a picture equal to a painting. Robinson wrote the book on this subject, *Pictorial Effect in Photography*, in 1869. Straight photographers argued conversely and convincingly that such intervention betrayed scientific objectivity—that realm of photography to which painting could only aspire. Painters were apt to find photomontage weirdly real; photographers, really weird. Needless to say, this offspring of science and of art was acknowledged by neither parent.

Can photography be an art? Both sides have their old generals who tirelessly marshal their arguments and contest their paper battles to inevitable victory while we, their adopted grandchildren, nod knowingly, and then nod off. We acknowledge the difference between good photographs and those we take. We distinguish between fine paintings and those we make. Whether one or both or any or all are artistic is personally defined and anyone else's dictate, soporific.

But Robinson and Rejlander proved a more enduring point: namely, a photograph (if not the camera) could lie. To the argument raised (facetiously perhaps) by the late nineteenth-century etcher Joseph Pennell and his contemporary, the pre-Raphaelite landscapist John Brett, that photography could not be art because it had no capacity for lying, Robinson responded in 1892 that photomontage was capable of a "useful falsehood."[2]

Photomontage was not only capable of falsehood, it was a habitual liar. If straight photography could do no less than tell a truth, it also could do no more. Photomontage could not but do more. Once two negatives of things actually seen are conjoined, the composite positive absolutely was not, and never could be, seen. Photomontage is as unreal as can be. Its unreality is the very thing that endeared it to the artists of constructivism, dadaism, and surrealism in our century. Is photomontage a lie? Invariably so. Is it a darkroom trick? Admittedly so. So what? So what indeed.

The general tendency of photomontage of the past century is toward paradoxical

2. Henry Peach Robinson, "Paradoxes of Art, Science, and Photography" (1892), quoted in *Photographers on Photography*, ed. Nathan Lyons (Rochester, N.Y.: Eastman House, 1966), p. 82.

juxtaposition and away from the deceptive humbuggery of Rejlander. No one is duped to believe that Toulouse-Lautrec could be simultaneously portraitist and sitter, as he twice appears in Maurice Guibert's 1890 photomontage. No one is deceived to think that the Marchioness Casati has four eyes, as Man Ray doubled them in his 1922 montage. No one thinks that a swan can swim on marble just because Scott Mutter shows us one doing so. Painting could do this also, but not as well. Such photomontages are as straightforward with the viewer as a straight shot, and they add immeasurably to the photographer's vocabulary. Straight photography speaks in the objective case: what things are. With Minor White it can move from the objective to the subjective: what else things might be.[3] Photomontage adds the subjunctive: what might they be if they were.

Photomontage could conceptualize the intangible, the root of much of modernism. It suited the Berlin dadaists and their disillusion with the illusions of bourgeois art. As one of their party, Hannah Höch, wrote: "The Dada photomonteur set out to give to something unreal all that had been photographed. . . . our whole purpose was to integrate objects from the world of machines and industry in the world of art."[4] To this purpose George Grosz and John Heartfield deconstructed old photographs and disordered the pieces into collages or montages of wickedly satirical political propaganda.

Photomontage suited the attempts of the constructivists El Lissitsky and Rodchenko to alter their vision of the material world and thereby envision alterations. Photomontage gave a palpability to the French surrealists' world of dreams. Even the single images of Man Ray, Raoul Ubac, and Hans Bellmer have double meanings leading Rosalind Krauss to assert: "In the case of Surrealist photography, the image is *always* manipulated quite independently of whether montage, double-exposure or solarization have intervened."[5] Photomontage, anchored in reality but capable of artful manipulation, was the perfect vehicle for the modernist movements beyond matter-of-factuality. Of them, surrealism made the most enduring impress on the public imagination. The term, unleashed of its psychology, has entered the lay vernacular. Today, any quirk of reality is defined as "surreal."

For this reason, when Scott Mutter shows a grove of trees sprouting from a parquet floor, it is unimaginatively described as surreal. In reality it is not. Any allegiance to surrealism or photographic precedent had to be unconscious and peripheral, since Mutter, though he studied many things, did not study photography until he was ready to make photomontages. Mutter's experiments were self-styled—which, as Sadakichi Hartmann wrote in *Camera Work* in 1910, is the only path to creative photography: "If new laws are really to be discovered, an acquaintance with the various styles is prejudicial rather than advantageous, since the necessary impartiality of ideas is impossible, inasmuch as the influence of study and the knowledge of preexistent methods must inevitably, although perhaps undesignedly, influence new creations and ideas."[6] Robinson, Rejlander, Man Ray, Minor White, Harry Callahan—all were photographers who went against the grain. Like them, Mutter came to photography through the back

3. Minor White, "Memorable Fancies" (1952), quoted in Mike Weaver, *The Art of Photography, 1839–1989* (New Haven: Yale University Press, 1989), p. 341.

4. Quoted in Van Deren Coke, *The Painter and the Photograph* (Albuquerque: University of New Mexico Press, 1964), p. 259.

5. Rosalind E. Krauss, "Photography's Exquisite Corpse," *In the Mind's Eye: Dada and Surrealism* (Chicago: Museum of Contemporary Art; and New York: Abbeville Press, 1985), p. 56.

6. Sadakichi Hartmann, "On the Possibility of New Laws of Composition" (1910), quoted in *The Art of Photography*, p. 160.

door—photomontage being his solution to inquiries into history, culture, language, and art.

Film introduced Mutter to montage. He studied cinematography as a post-postgraduate student at the University of Illinois at Urbana-Champaign in 1971–72 and for fifteen years codirected the Expanded Cinema Group, a student-oriented film program. Film offers a close and daily encounter with the special effects of photomontage. Without superimposition, blue screens, and painted transparent cels, Woody Allen couldn't interpose himself as *Zelig* into historical footage, Luke Skywalker couldn't stare deeply into the stars of *Star Wars,* and animation wouldn't be fully animate. But superimposition is only one aspect of cinematic montage as described and raised to an art in the 1920s by the Russian filmmakers Lev Kuleshov, Vsevolid Pudovkin, and Sergei Eisenstein.

To them montage was *the* art of filmmaking. The motion picture camera records the action it sees in a sequence of straight photographs. By editing together images that occur out of sequence, the filmmaker can quick-cut to different places and times, juxtapose angles, repeat an image, or in any other way bring into relationship elements that are not actually related in nature but might be related naturally. The viewer is activated to assemble and incorporate these pieces into a new unity as the edited frames are projected seamlessly onto the screen. Filmmakers speak through montage, even in their silent movies. Eisenstein practiced what he preached, and Scott Mutter read his sermons.

It struck Mutter that he had encountered the fundamentals of montage before and at the very root of all communication—the written word in the Chinese language. Mutter's first master's degree, in 1968, was in Chinese area studies. Chinese calligraphy, as he told me in 1987, is pictographic: "The symbol for every basic material object is a drawing of that object. Century by century these drawings became abstracted and in the process the drawings themselves became an art form. But if one looks back at the various stages of the abstraction, it becomes clear that the present image is a balanced shorthand of those objects. Of course, no language is made up solely of object words. Concept words were formed by taking an essential portion from two or three or four objects that had some bearing or relationship to the concept."[7] Chinese, Mutter said, is "image montage."

On reflection, Chinese is not unique in this regard. One need only consider the German propensity for compounding noun upon noun to make more complex nouns or the hyphenated adjectives in English usage to recognize that languages universally invent composites when their root words are insufficient to express a grander notion.

The means by which Chinese scribes composed communications at their scholars' tables—or the filmmakers in their editing rooms—seemed, to Mutter, to be possible in the darkroom. He had the ammunition in 1973, but he lacked the gun. That year, at age twenty-nine, he bought and used his first camera. Four months later he produced his first photomontage, the success of which amazed him as much as anyone.

Like their pictographic antecedents, Mutter's photomontages are composite pictures of objects which when joined together assume a new and more complex definition. Their readings may differ, but they are always eminently legible.

There is a certifiable tendency among those engaged by Mutter's work to pull it to pieces, to distinguish the elements and landmarks he has so carefully selected for their irreducibly perfect fit and so painstakingly bonded together. It is an admittedly perverse pleasure, and one to be recommended (were it not for the fact that it is such a

7. Quoted in *The Photomontages of Scott Mutter,* ed. Martin Krause (Indianapolis: Indianapolis Museum of Art, 1987), n.p.

natural impulse as to recommend itself). No one I've encountered or heard of or read the comments of in the guest books Mutter puts out at his exhibitions ever debunks his work. Rather, they parse it. They diagram the photographs as if they were sentences, breaking out the elements (like modifying parts of speech) in order to decipher Mutter's processes, and then mentally reunite them as Mutter had done. They wonder at it.

Humor and magic are found in Mutter's work. He is by nature neither a comedian nor an illusionist. When once asked to lecture on the humor in his art, he was at a loss, because to him it isn't intentionally funny. His work, like all photomontage, is incongruous, and this it shares with humor and magic. Comedian and magician establish a set of circumstances whose outcome is so predictable that everyone in the audience races ahead to it—then out pops the punchline or the unanticipated rabbit. The viewer of a photomontage expects one thing from the ever-truthful photograph but is confronted by something completely different. He or she may ask, What is wrong with this picture? With Mutter's work, the question is, What is right with this picture?

There is a certain rightness (not wrongness) to Mutter's grove of trees springing from a parquet floor, for the floor of a woods should be wooden flooring. Chicago's Amoco building *could* finish in a Corinthian capital like the one Mutter appropriated from the J. Paul Getty Museum's peristyle, for Edward Durrell Stone's 1974 neo-neo-classical tower has everything in common with a Greek column: clean lines of fenestration quote from a column's fluting, and conceptually both are pillars of society. A postmodernist architect might conceive such a likely fantasy, but only Mutter could realize it.

All of Mutter's photomontages ring true. They may not be factual images, but they are plausible. For all intents and purposes a straight photograph tells a basic truth; a photomontage does not. Photomonteurs have the capacity for stacking one truth upon another, of seeing beyond sight and making seen, and, once done, of truly creating a thing that is to be believed. That the camera doesn't lie is not exclusively virtuous. It is certainly not vicious that the photomonteur can. To falsify is one thing, to fabricate is quite another.

<div style="text-align: right;">Martin Krause</div>

Preface

The idea of creating a montage by combining two or more photographic images is nearly as old as photography itself. In 1869, Henry Peach Robinson, a combination printer of great professional and popular appeal, published *Pictorial Effect*. His book was not one of images so much as it was of his ideas and theories on imagery and how he went about creating combination prints. Oscar Rejlander, circa 1860, also worked in this general form, which he referred to as "multiple pictures" (though the end result looked unified rather than multiple). The most successful of the modern monteurs—those who began to use the form to depict the invisible, the conceptual—was probably Herbert Bayer (1900–1985), whose work could be referred to as the "imagery of ideas."

I also have been influenced by a number of individuals and works outside photography. For example, the Russian filmmaker Sergei Eisenstein (1898–1948) developed a strong sense and theory of montage, which he wrote about in two books, *The Film Sense* and *Film Form: Essays in Film Theory*. Many of the ideas discussed in *Film Form*, a collection of twelve essays on film theory written between 1928 and 1945, can be transferred to still imagery. In one essay of particular interest to me because of my knowledge of the Chinese language, Eisenstein investigates Chinese and Japanese characters as image montage when they are in their copulative or abstracted/combines form, as opposed to their abstracted object-word form. Ernest Fenollosa's book *The Chinese Written Character as a Medium for Poetry* (1920), edited by Ezra Pound after Fenollosa's death, has also influenced my thoughts about montage.

Let me backtrack a bit and tell you something about my life and what I am trying to do. I was born in Chicago in 1944, several hours after the death of Edvard Munch and a stone's throw from the underground handball courts where atomic fusion had just been achieved. My mother was a teacher in the Chicago public schools and my father was a supervisor with the Chicago Park District. His father had served as a Chicago police officer from 1908 until he was killed in the line of duty in 1934; my paternal great grandfather was also a Chicago police officer, from 1878 to 1915. My maternal grandfather worked for the Pennsylvania Railroad in Chicago.

After what I can only describe as normal growing-up years with the wonders of Chicago and its lakefront as my playground, I entered the University of Illinois at Urbana-Champaign in 1961. I graduated in 1966 with a B.A. in history and associated fields, and in 1968 I received a master's degree, also from Illinois, in Chinese area studies. After a year at McCormick Theological Seminary in Chicago, I returned to the University of Illinois and began, on my own and as a part-time student, to study art history, mythology, and certain thinkers, especially Spengler and Jung. During this period I thought about ways to visually communicate my ideas about human nature and the nature of civilization. I worked in collage, using images from magazines and

books, and later took courses in cinematography, immersing myself in the study of film criticism. I began to develop a method of combining portions of one film frame with portions of frames from other footage, all of which I controlled so that the result would be short film pieces in which disparate images appeared to be welded and moving in relation to each other. What I was working toward was a combined picture that would elucidate some aspect of culture by reference of the parts to each other.

By 1973–74 I had moved from the study of film to the study of photography. I began thinking of ways to create photographic images in somewhat the same ways I had prepared myself to create filmic images, but with the added influence of the Chinese language. I had no background in photography; in fact, I had not held a camera in my hands before age twenty-nine. I was simply looking for a solution to a conceptual problem. I produced no body of "straight," or unaltered, images but chose to work strictly in photomontage. And I persisted in not producing until I had visualized what I wanted to accomplish and what I wanted to see on a sheet of photographic paper. This combined study of art history, film, and photography led to an M.F.A. degree in 1983 from Illinois.

In the commentaries that appear at the back of this book, I have written something about most of the images that follow, something of the thoughts and ideas I was trying to convey when I made them. In general, the idea comes first and then I attempt to find the elements that, when properly combined, will portray that idea in a visually interesting and accessible way. In some cases, observing an object or place triggers an idea for an image and I then begin to think of what the best completing elements or objects would be and where they might be found. There is also an element of serendipity, in that sometimes, like everyone during the creative process, I'll stumble upon an idea or form heretofore unanticipated.

A fair number of people refer to my imagery as surreal, and I understand the tendency to use this term. The reference has less to do with surrealism per se than with the general feeling that the images do not represent material reality but instead evoke a certain feeling of Other. I must point out, however, that the word "surreal" hides one important—maybe the most important—aspect of my work: namely, the rationality in these images. There is a feeling of rightness in the combinations, a tendency to nod to the truth of them, making these images not surreal but *surrational*. The elements generally have such an affinity for each other, in a structural *and* a conceptual way, that their assemblage seems to echo—or perhaps even prove the existence of—a phenomenon that we sense reflects some truth. The potential power of montage lies in this combustion of its fusing or colliding elements, resulting in the emergence of an idea or the origin of things that come to us from the past, things that are usually asleep within us but can be visualized, understood, and communicated to someone else. I try to approach photomontage as a conscientious process, and if the individual elements resonate correctly, a feeling, an awakening will be produced. I attempt to make images that are accessible and accepted once seen and are capable of turning the glance into a gaze.

Lastly, I feel that there has been a failure of ideas and a failure of principle in our visual arts. And I would like to say from my heart that art is no idle thing. People want to see something and be held in genuine wonder.

Acknowledgments

I truly appreciate the encouragement and hours of unsolicited help I have received from a great number of people and would especially like to express my deepest thanks to: Bob Auler; Saul Bass; David Badner; William Becker; the late Rosemary Coffee; Jack Coleman; Daniel Dejan; Bob Finch; Greg Friedman; Frank Gallo; Fred Gardephe; Pat Groehler; Mike Hack; Paul Hixson; Michael Intrator, of Black Box Collotype Printing; Kitto; Martin Krause; Dan Miller, of Crane's Chicago Business; Printworks Gallery, Chicago; Joe Schrader, of JMB Realty, Chicago; the late Art Sinsabaugh; Luther Smith; Roger Stein; Charles Sweitzer; Henry Tabor, of Kroch's and Brentano's in Chicago; Tom Valeo; and Dirk Wales.

Thanks also to: the University of Illinois, in the capacity of alma mater; the communities of Champaign and Urbana; the patrons of B & Z's, for their extremely helpful insights and their interest in my beginning years, and specifically Frank Garvey, Deb Good, Kirk Little, Ken Segan, and Eugene; and especially Richard Palmer, my mentor.

Finally, my thanks to the many people in Chicago who have believed in my work and to those who have helped me gain access to locations for shooting the objects needed for some of these montages.

Surrational Images

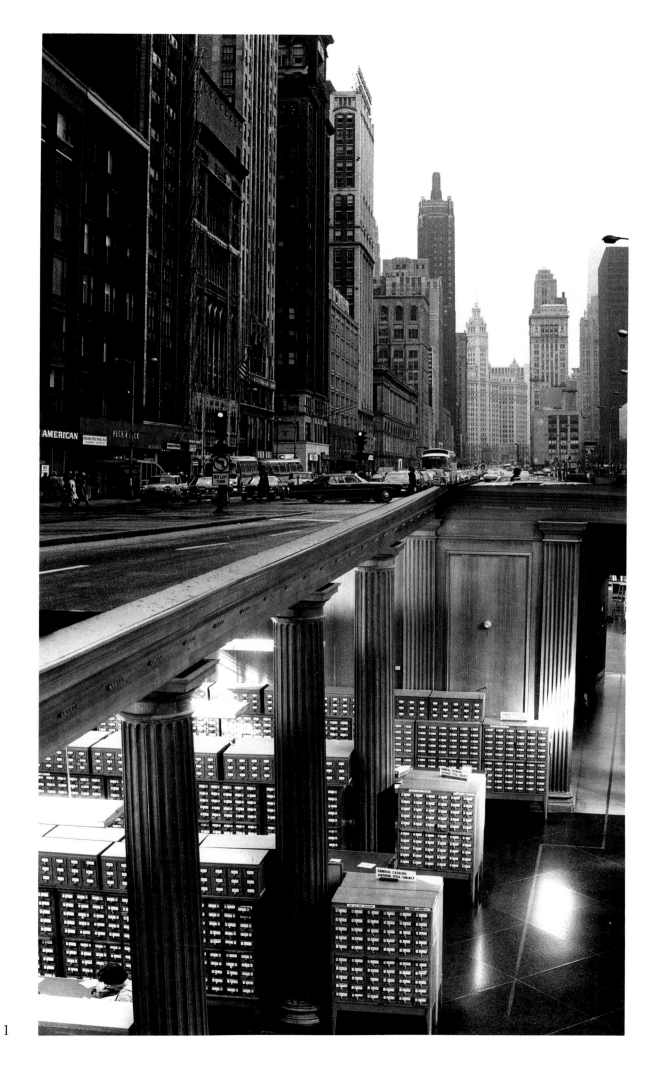

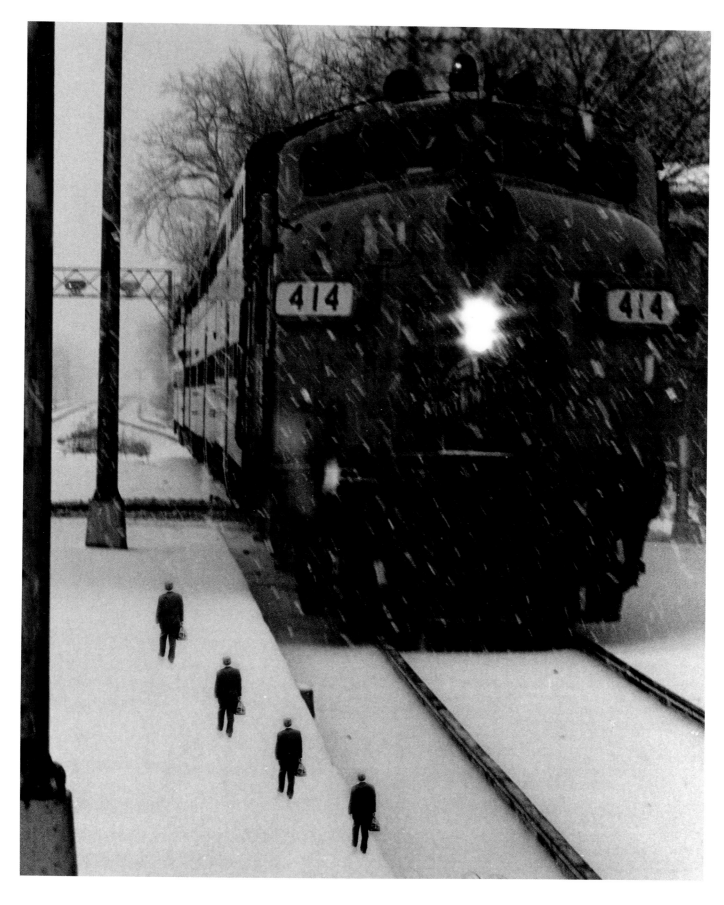

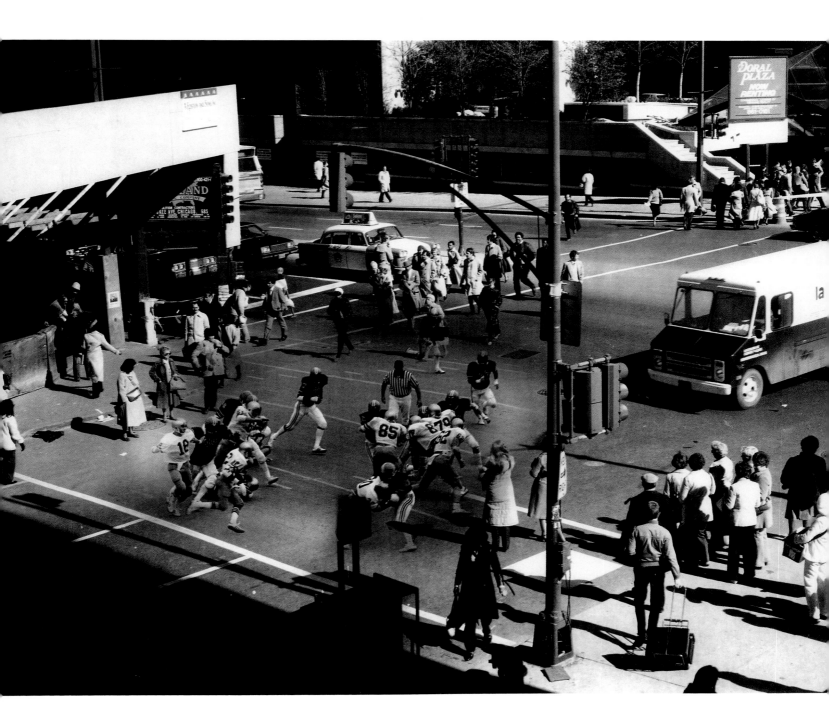

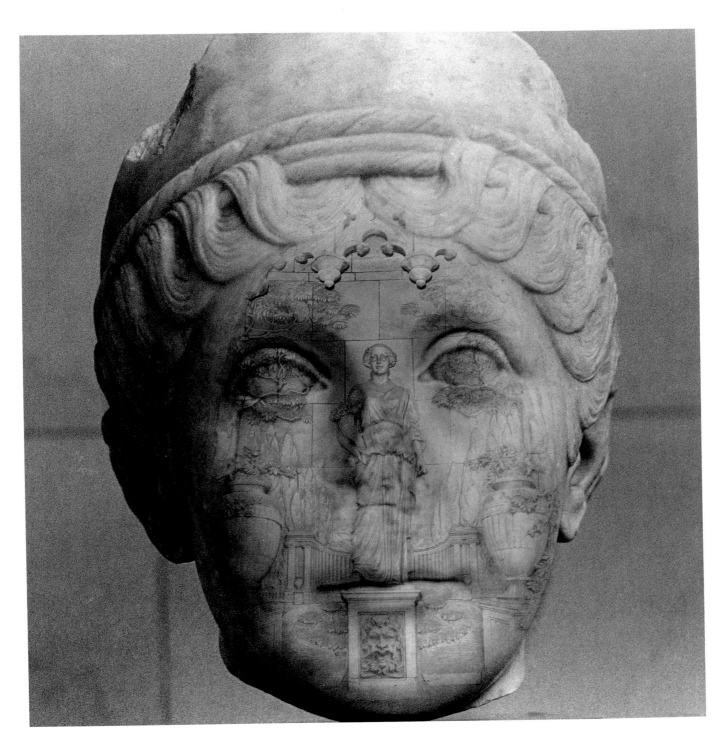

4

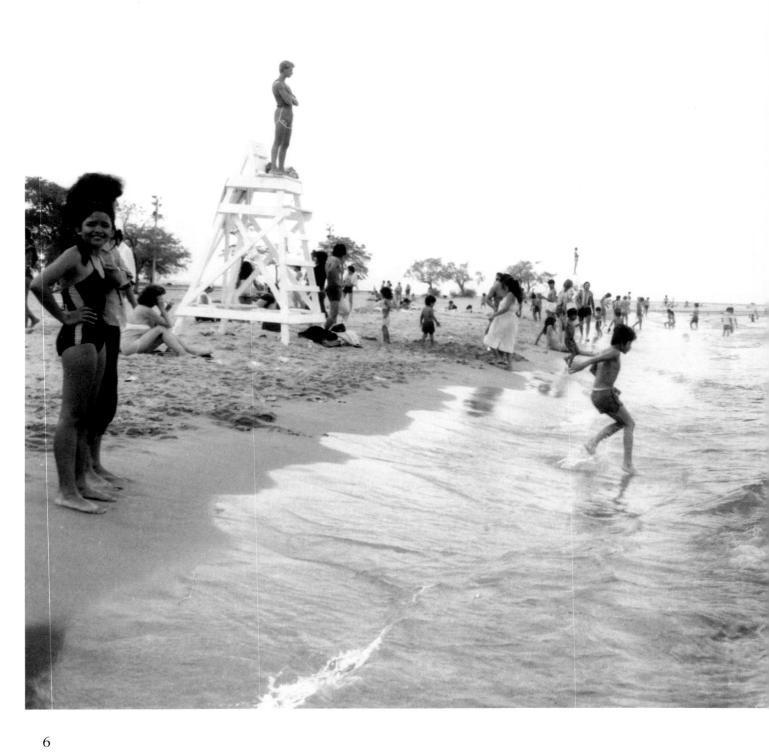

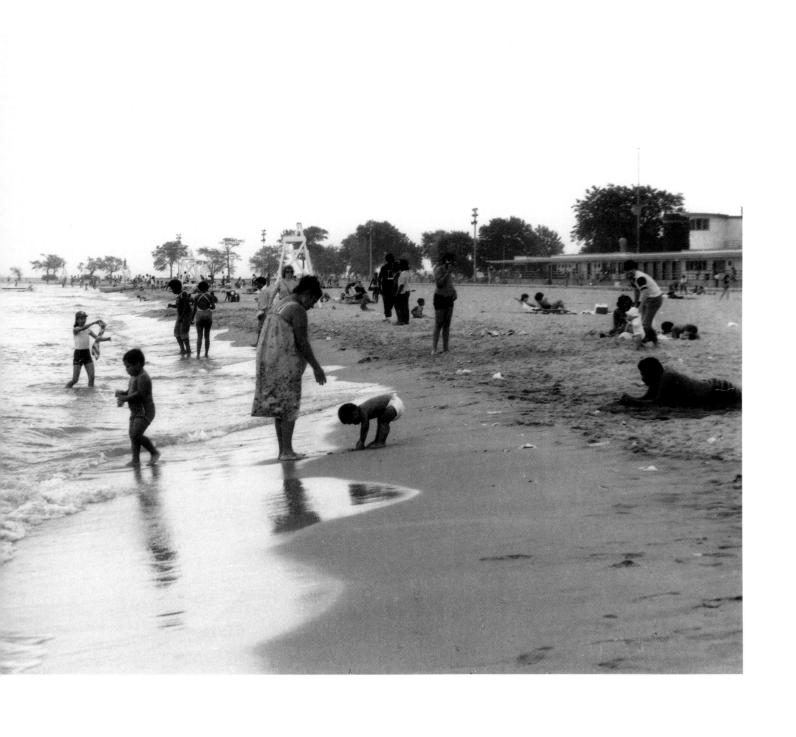

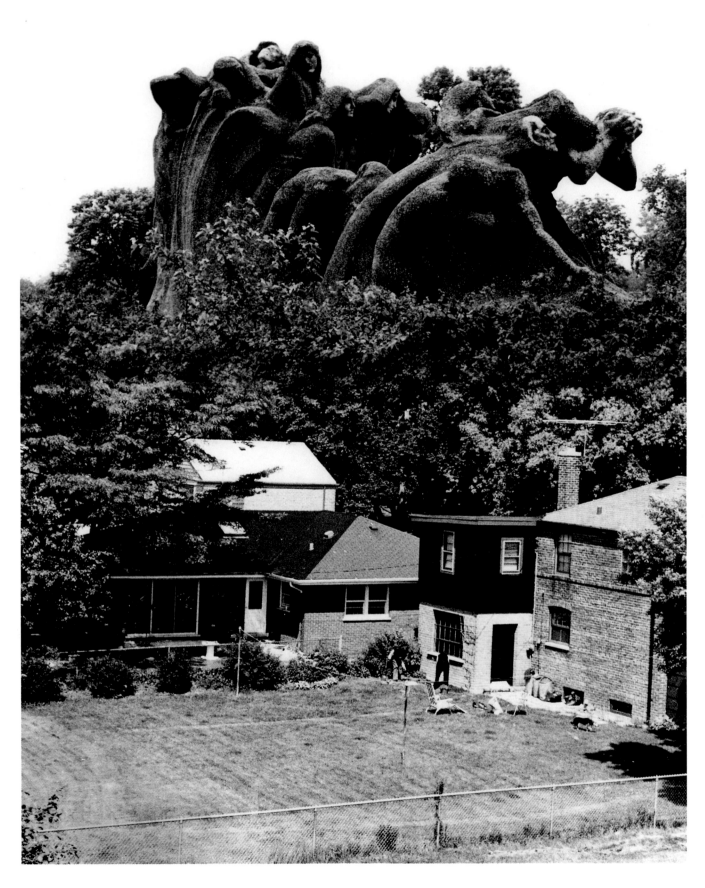

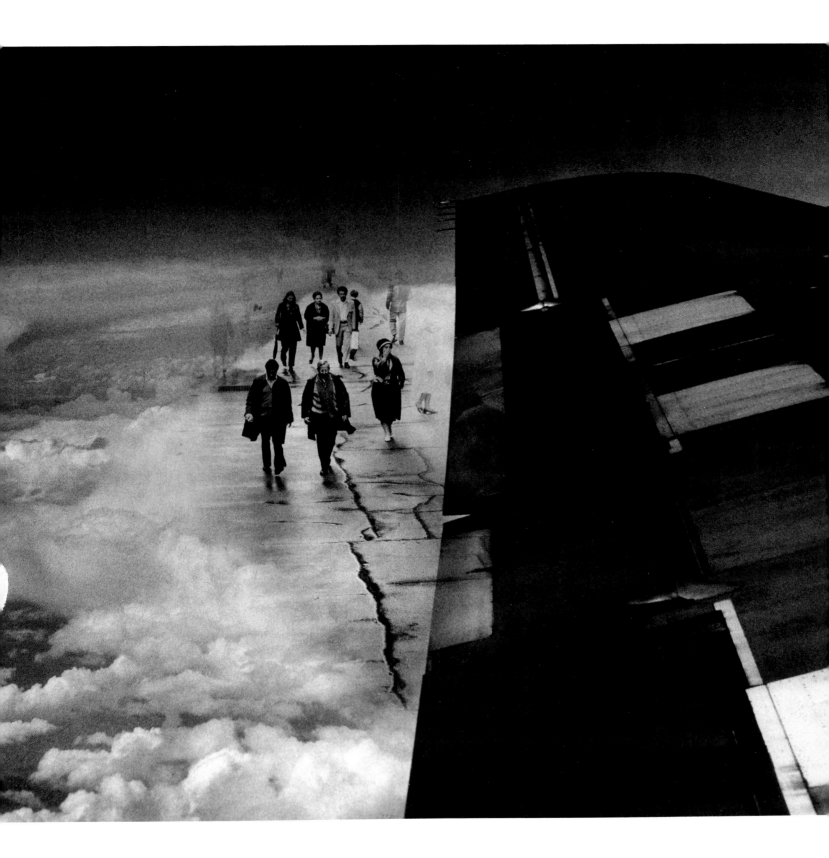

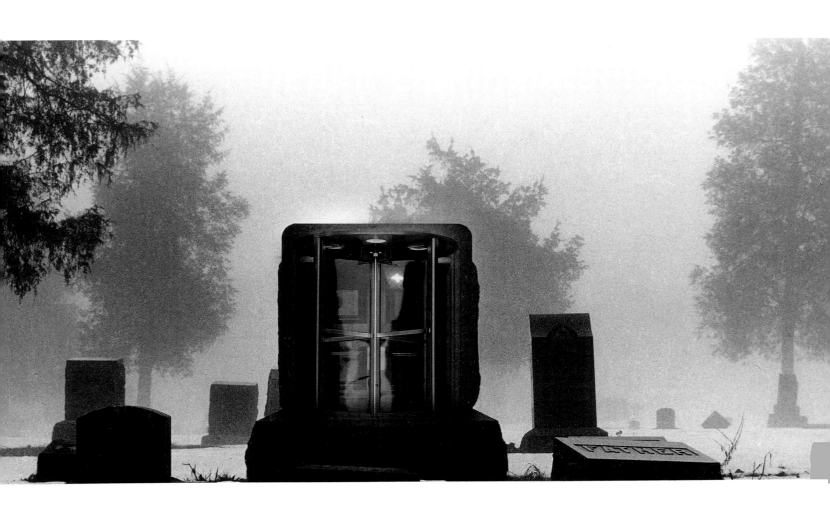

9

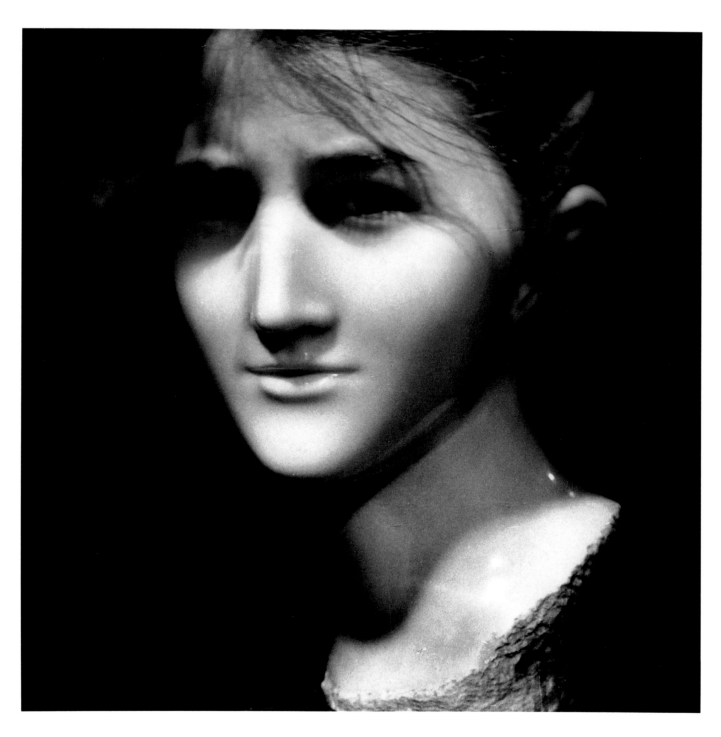

10

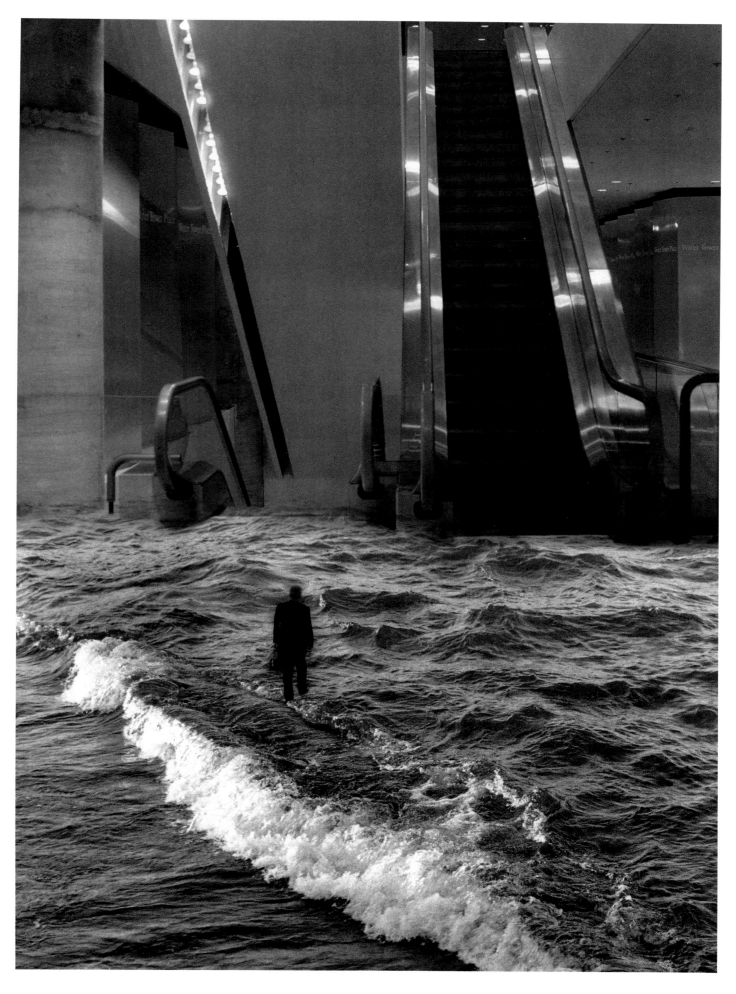

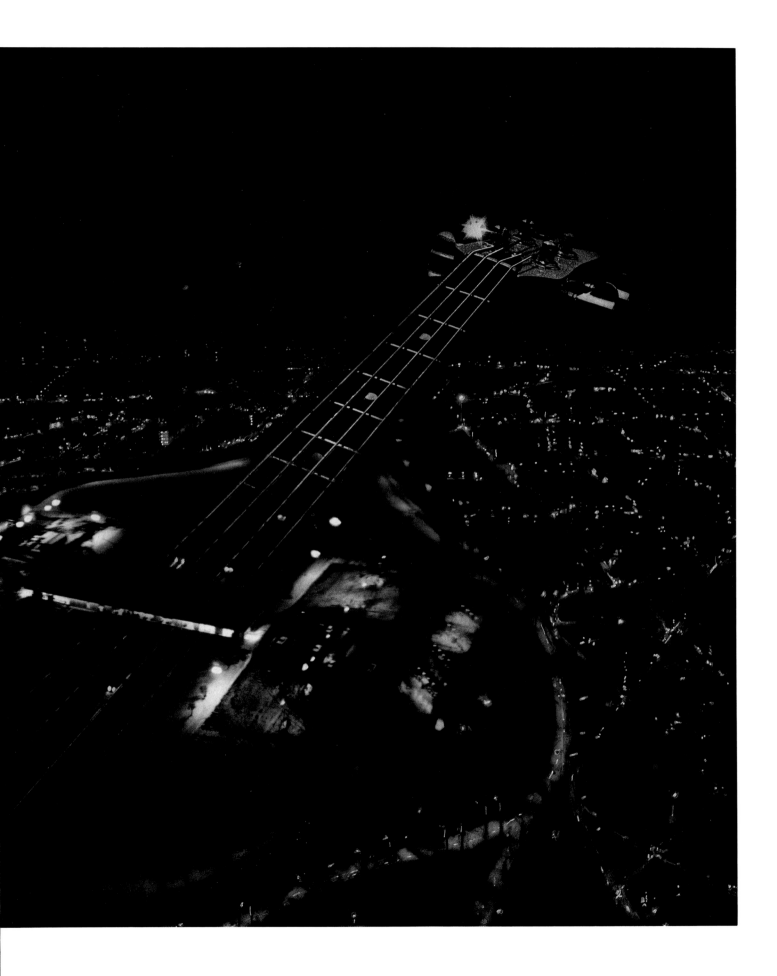

13

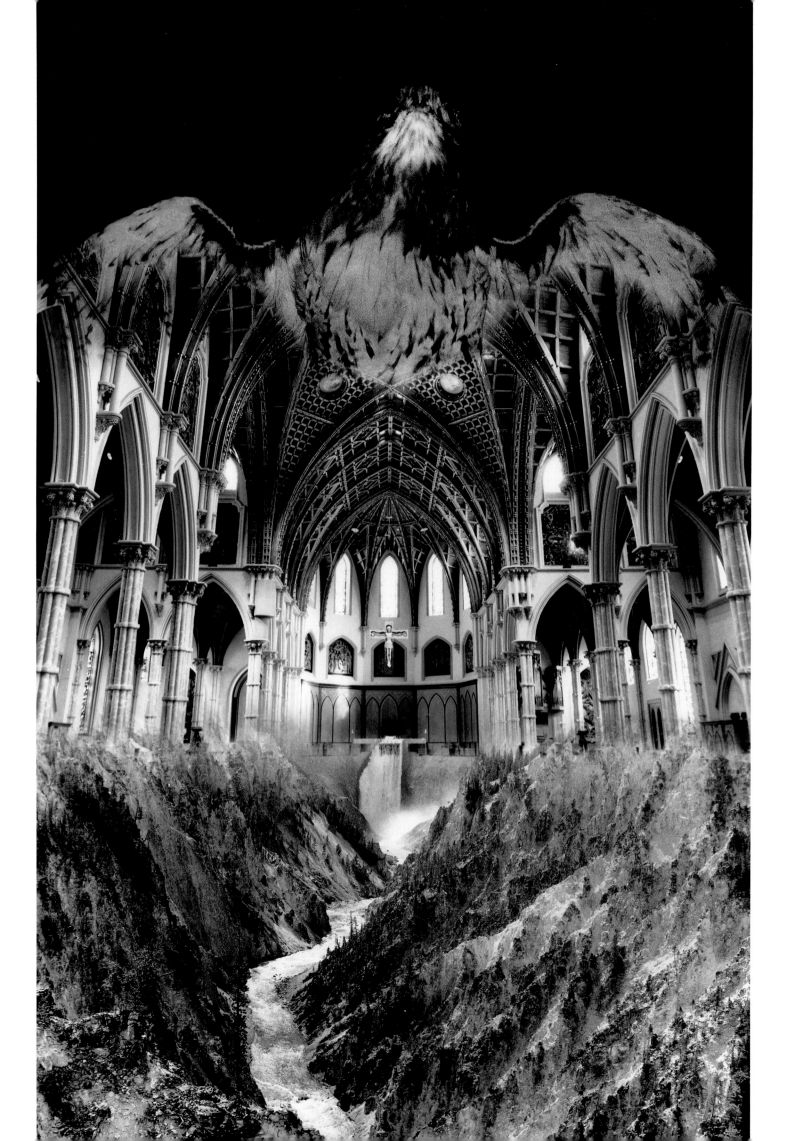

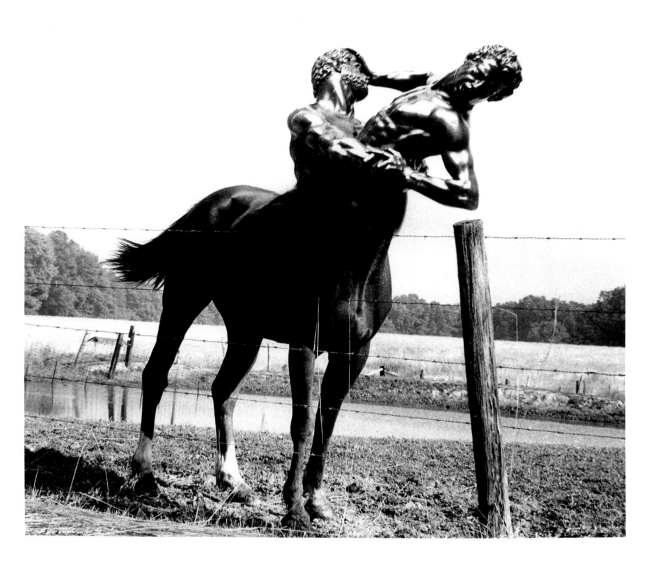

15

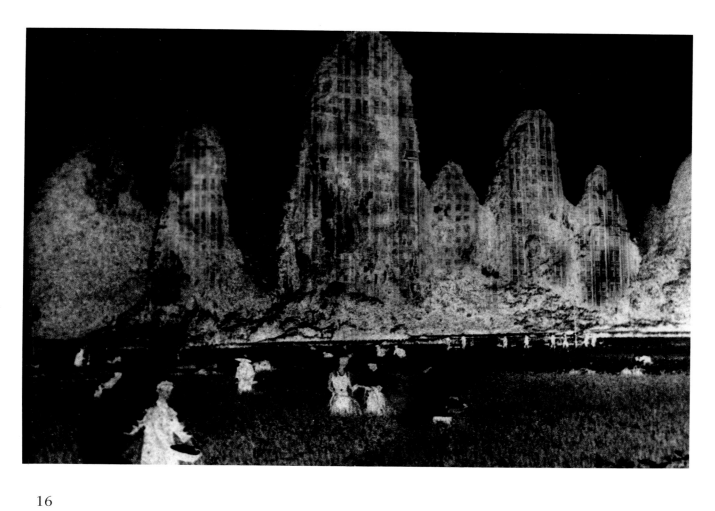

16

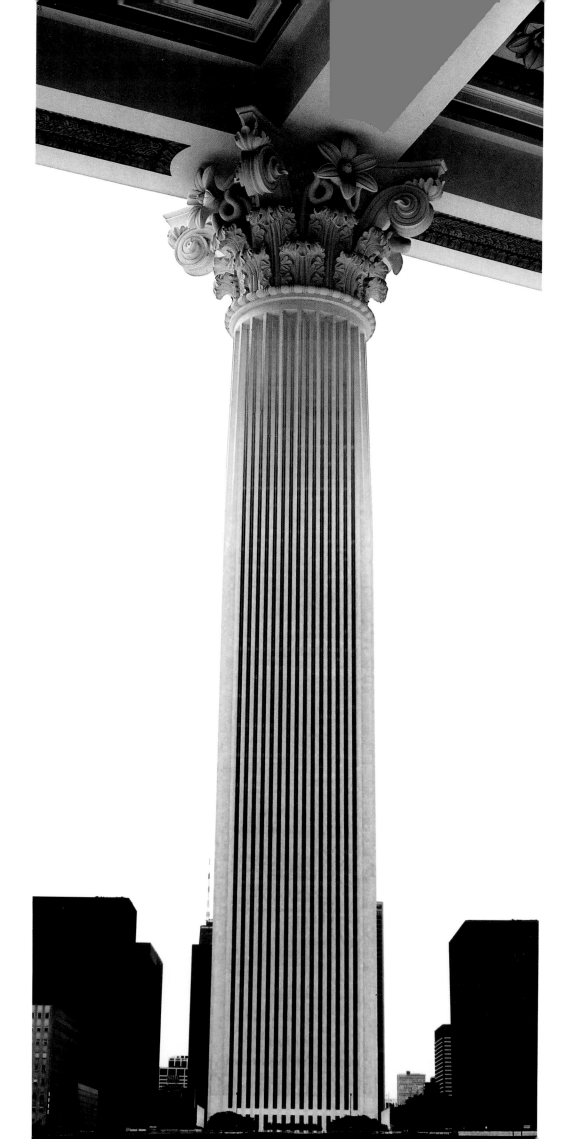

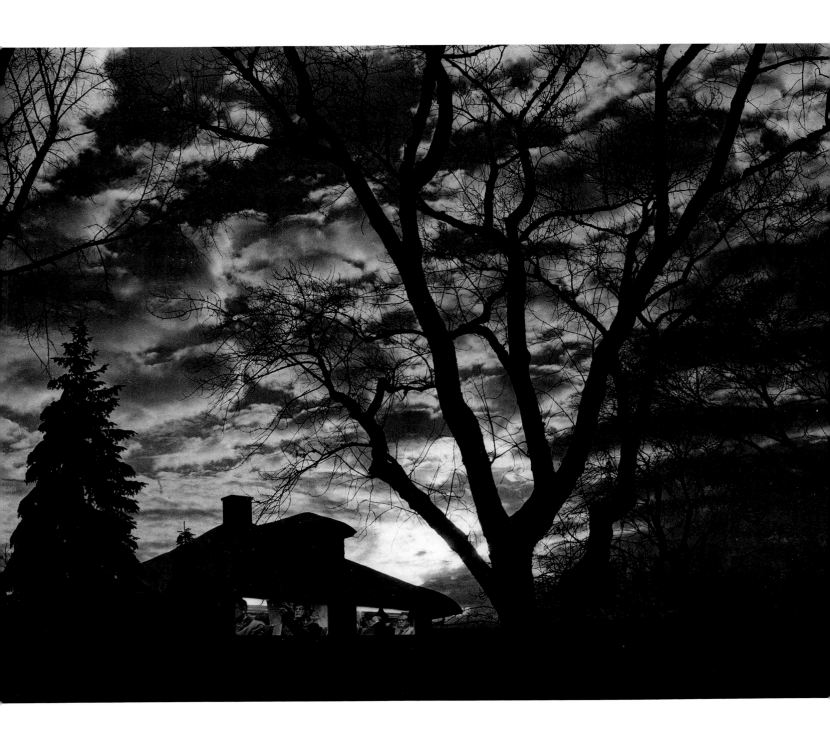

18

19

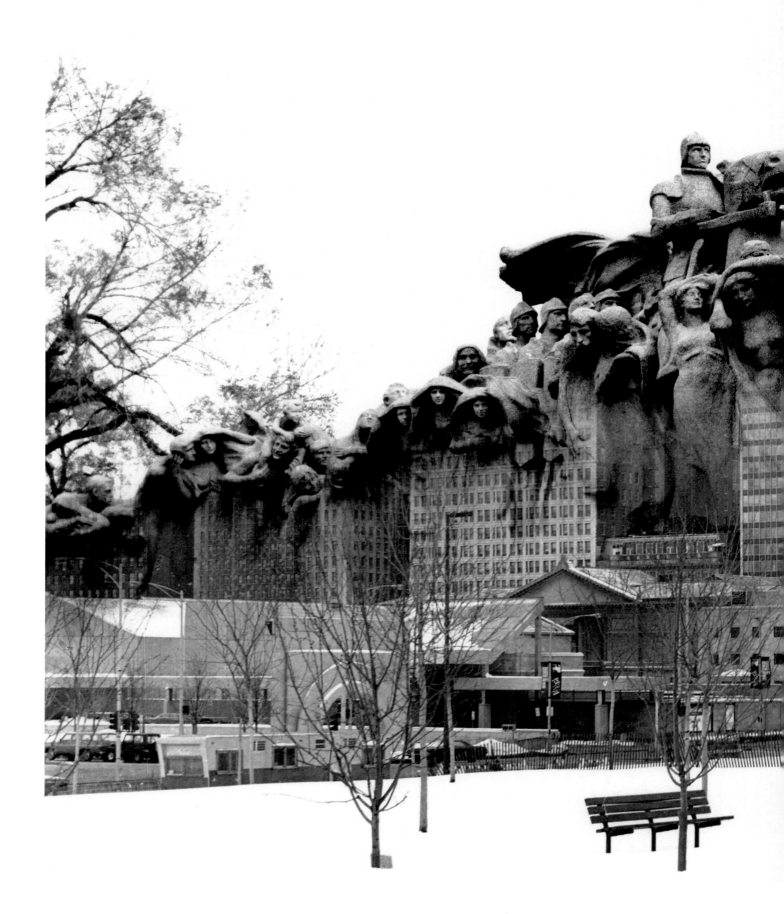

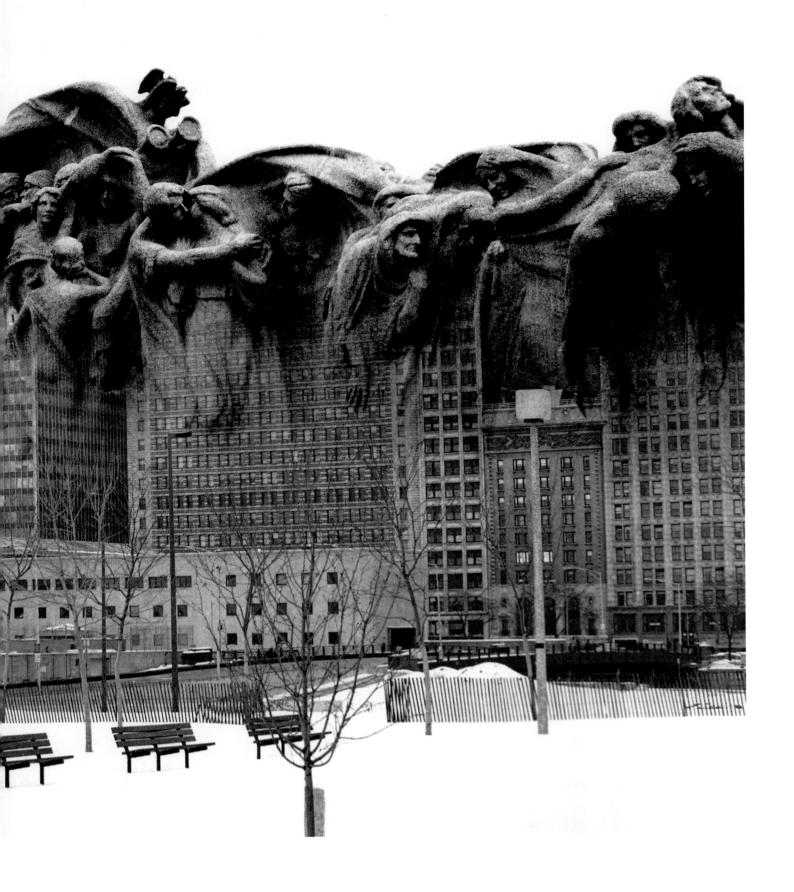

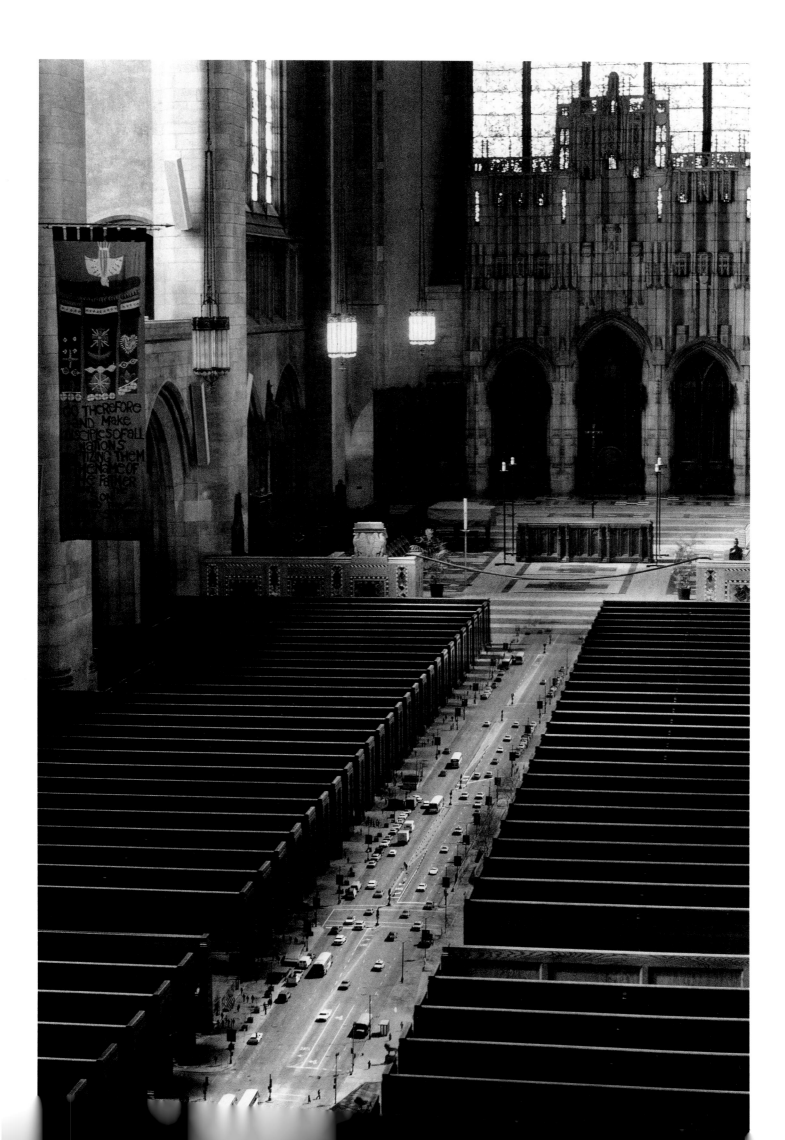

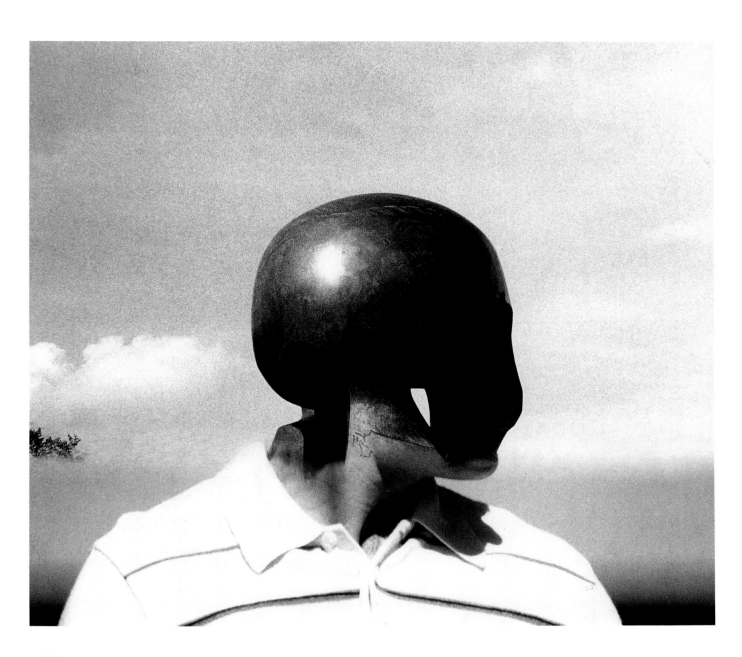

22

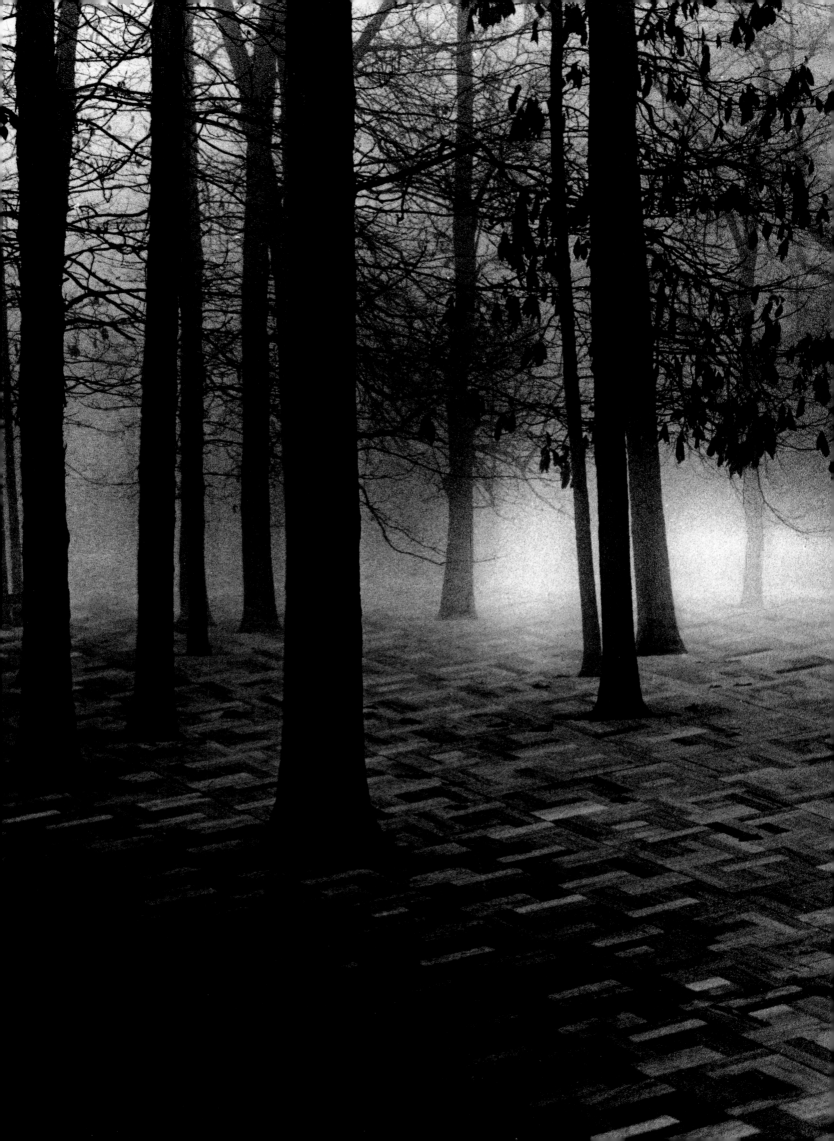

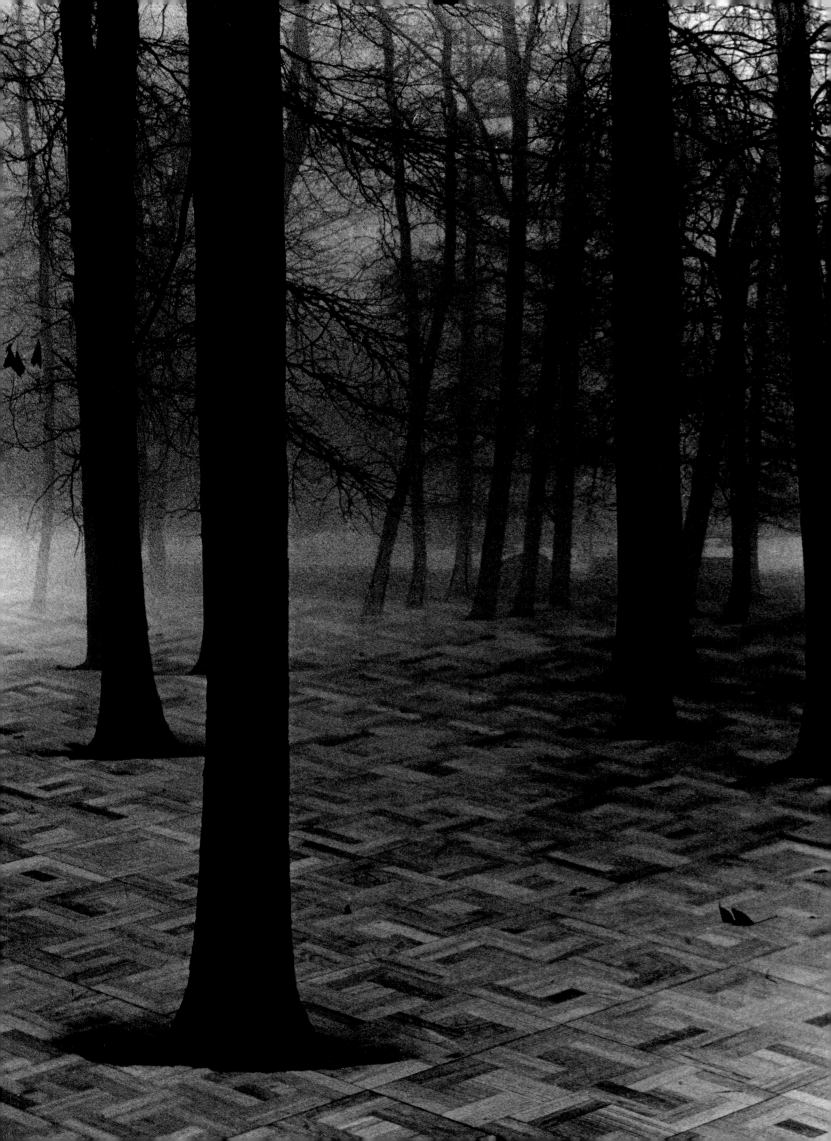

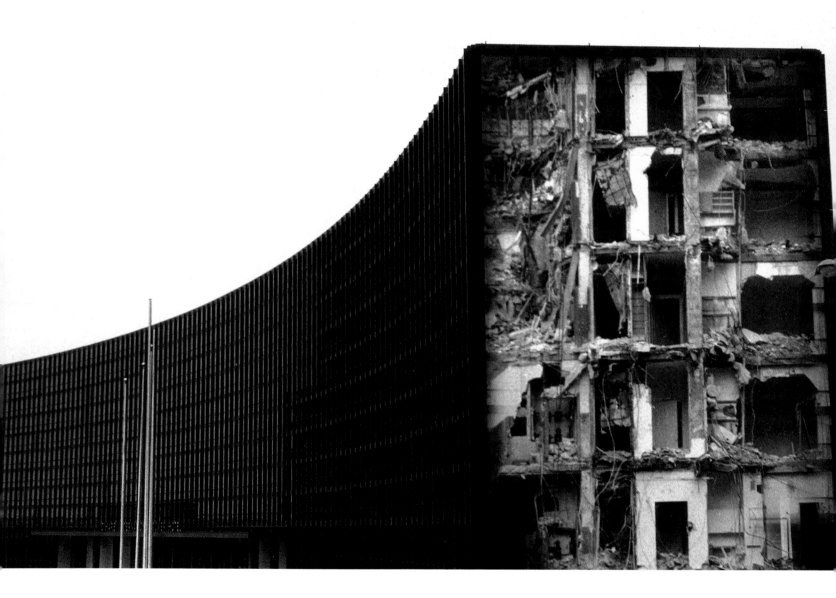

24

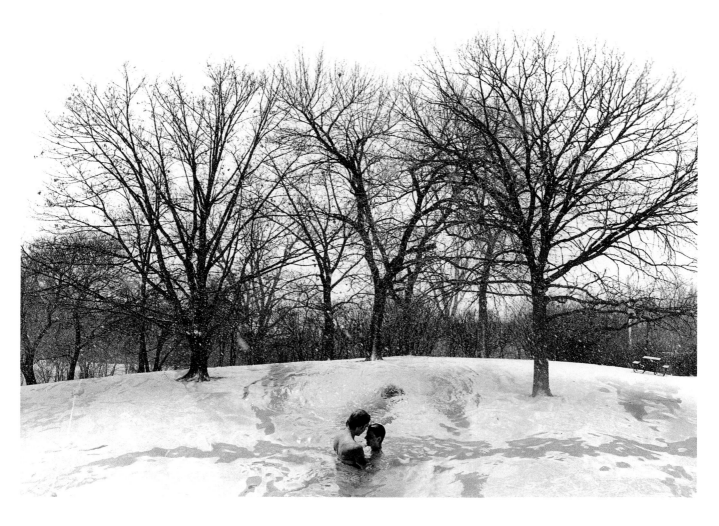

25

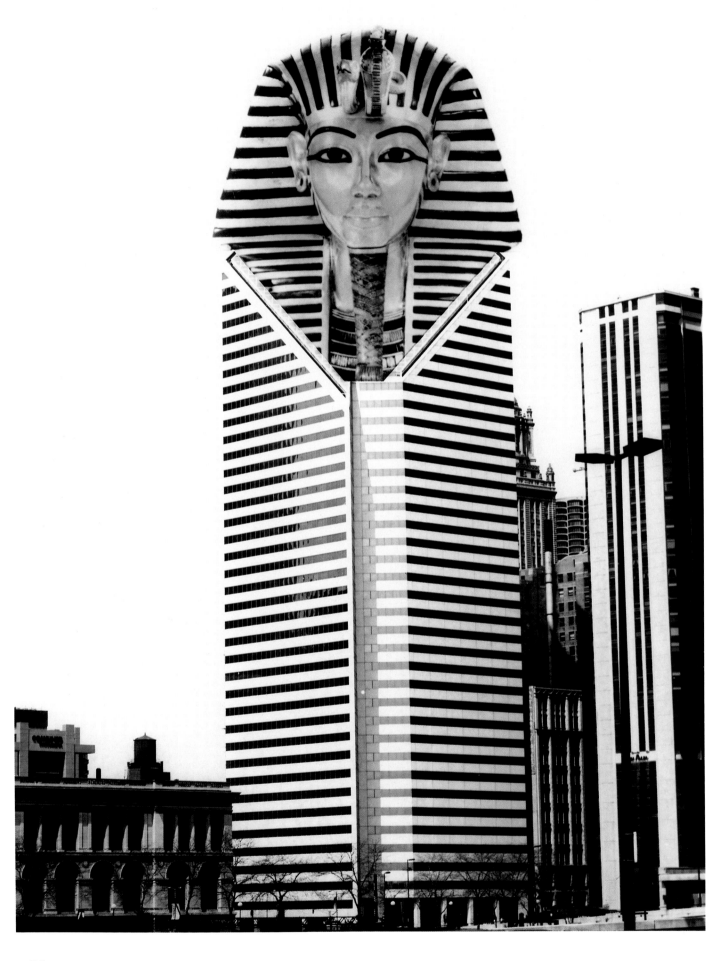

26

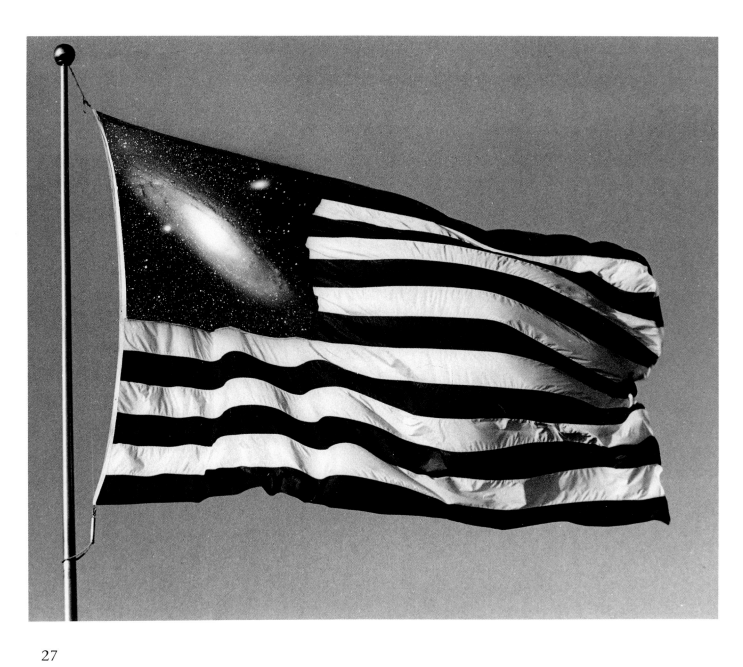

27

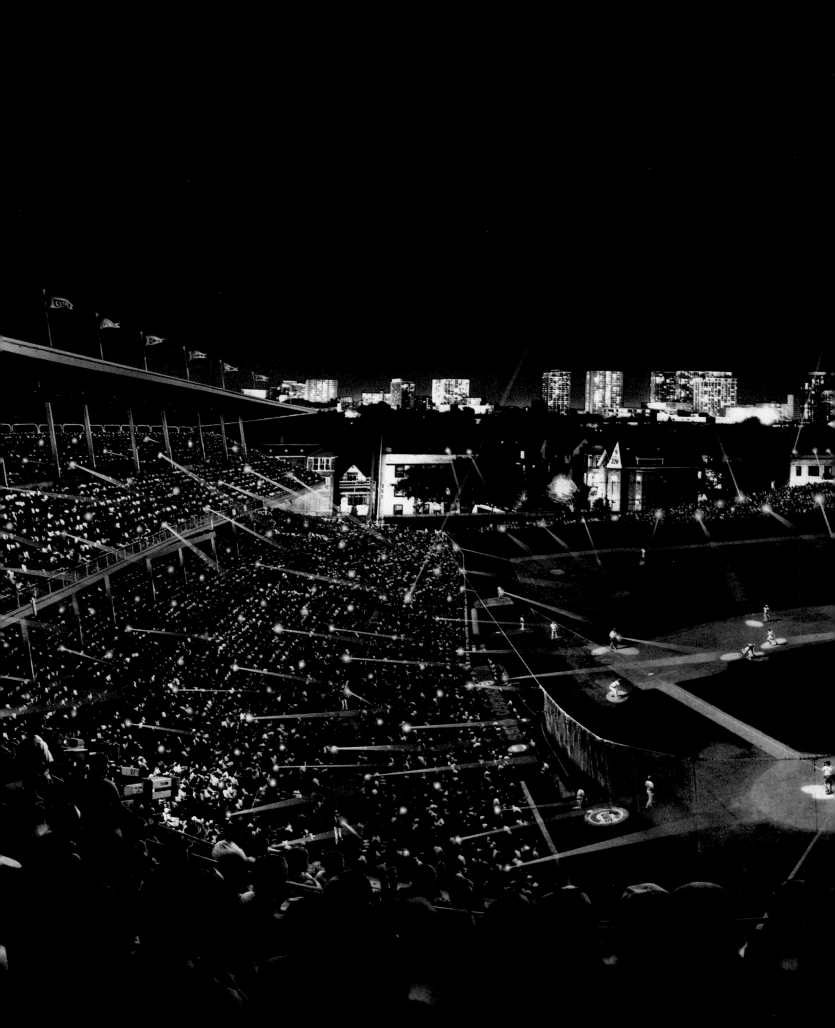

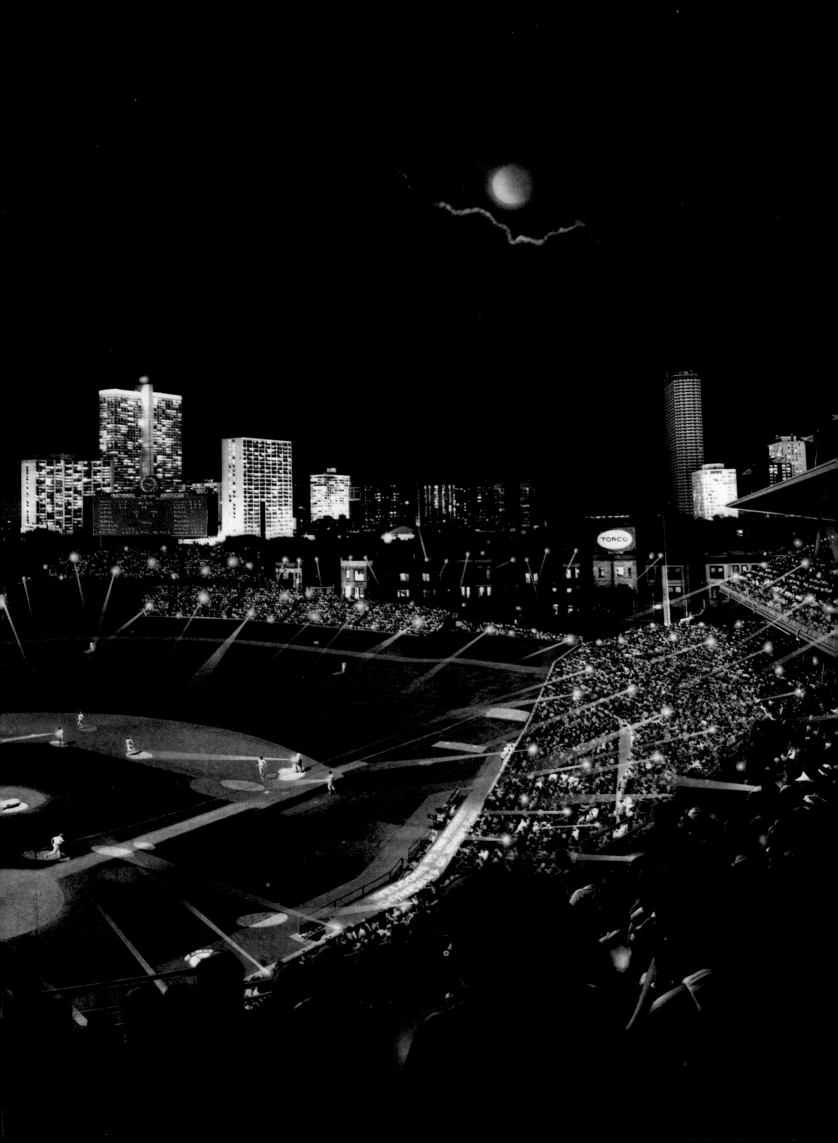

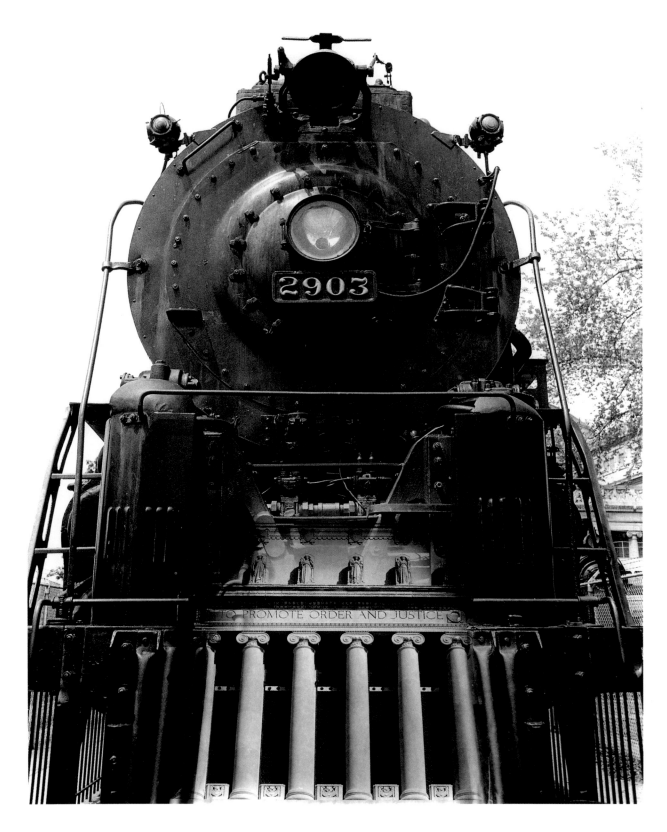

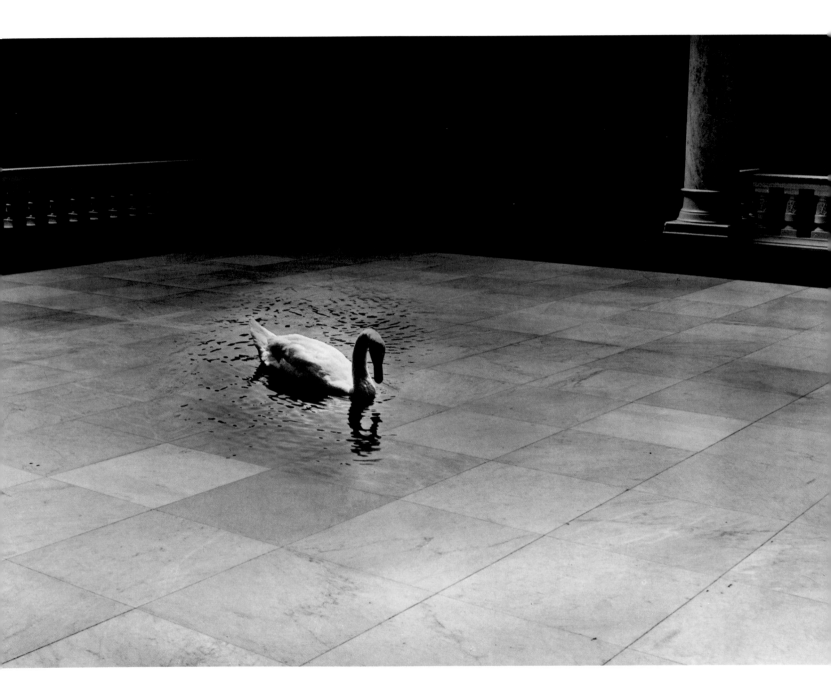

30

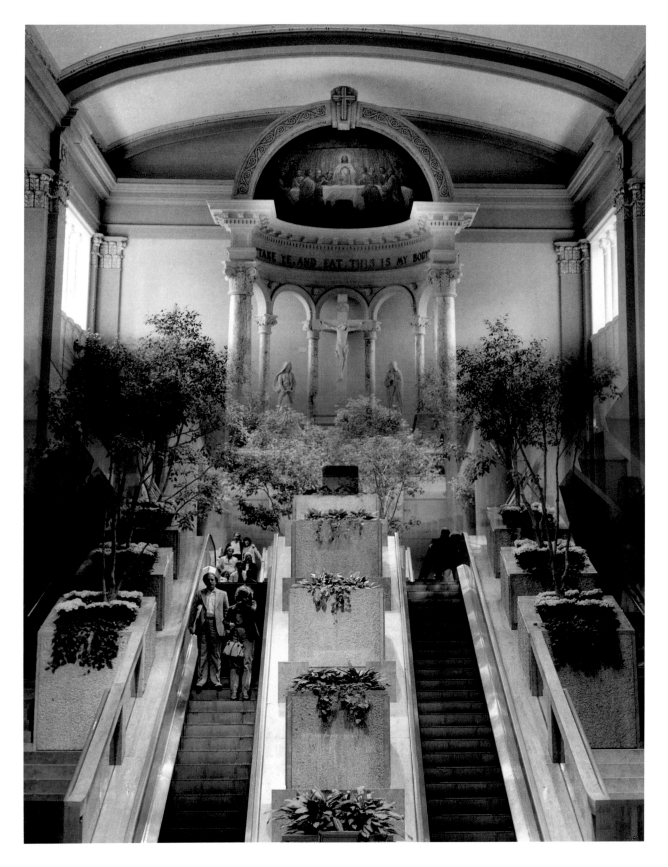

31

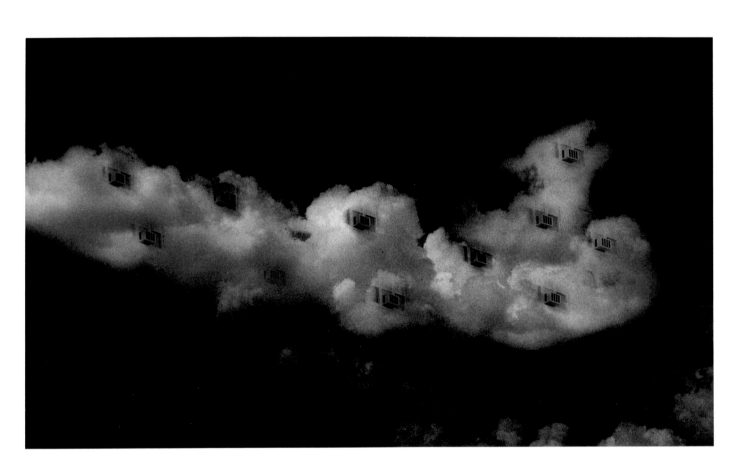

32

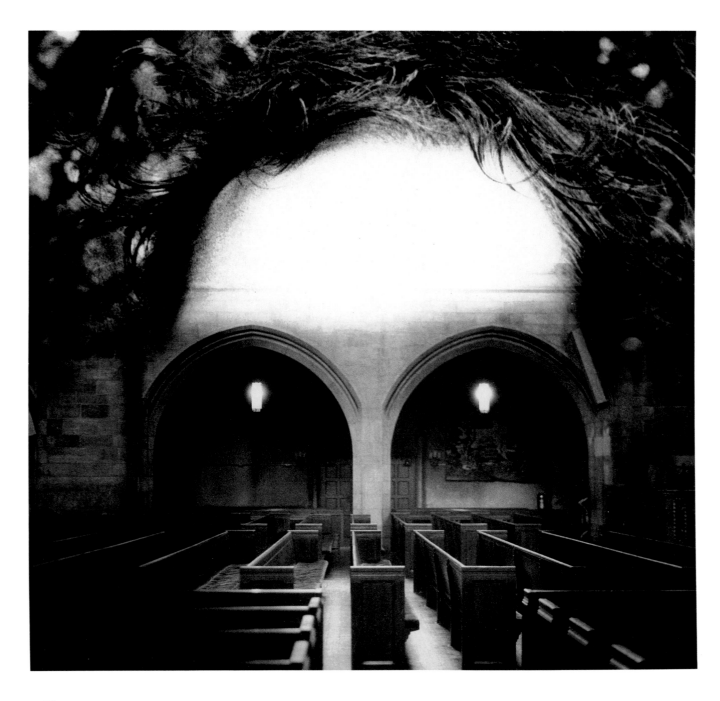

33

34

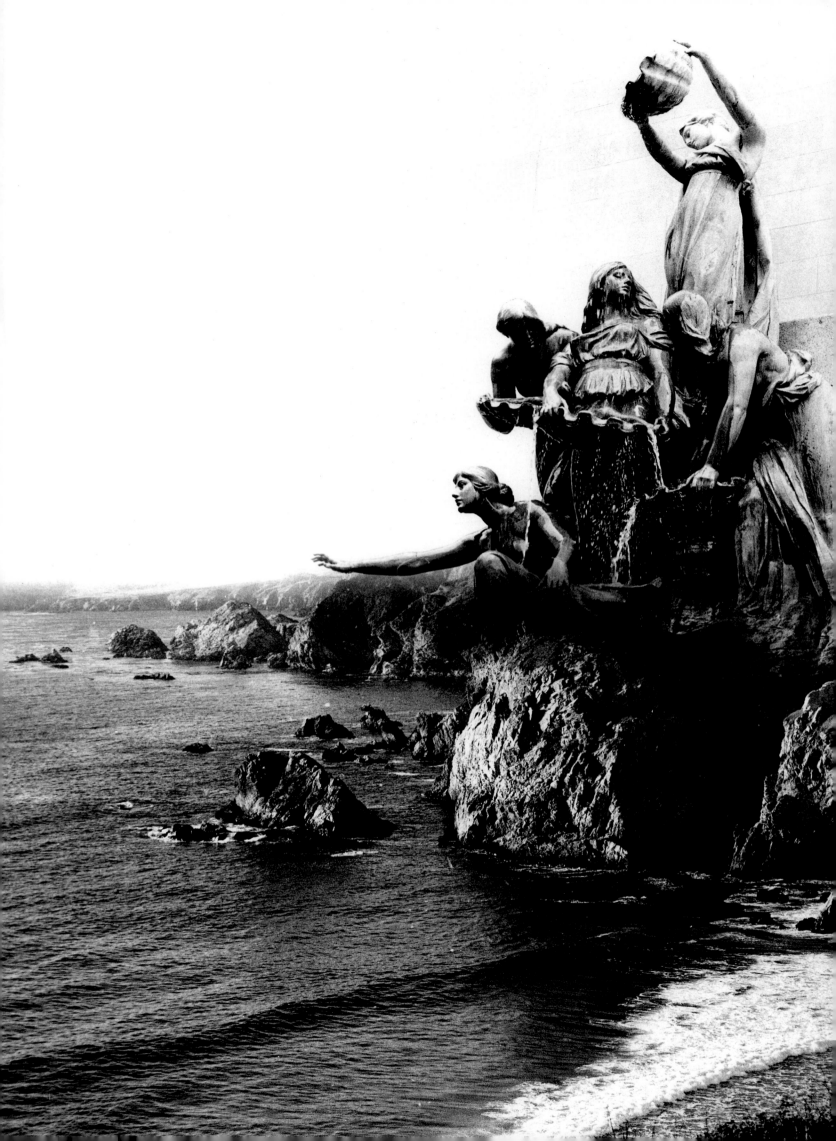

The Images

1. This combination of images gives form to an abstract idea: that a culture and what it produces are made possible by and are reflective of the knowledge that underlies that culture. Beneath the city streets are the card catalogs of knowledge—of science, legal systems, mathematics, behavior, social organization, architecture—that are indispensable for supporting the entire top section in all its material and nonmaterial processes. The pillars that appear among the catalogs allude to and emphasize the idea that knowledge does indeed hold up our cities, our nation, our society. If we were not able to store and retrieve this information we would relinquish our knowledge of all we have learned.

Note, too, the similarity of shapes and structures of the upper and lower levels. The card catalogs resemble the buildings above, and the drawers resemble the countless windows of those buildings. Both levels are based on the compartmentalization of function.

I chose the main library at the University of Illinois at Urbana-Champaign for the bottom portion of this image because of the twenty-odd years I was enrolled at Illinois and the countless hours I spent in the library.

2. Snow blowing across the front of a train. It's a train. It's not a train. It's a metaphor for industrialized society. It's on track, headed for a predetermined end. It's a large piece of machinery. Each time I stand by a train I think, My goodness this is so large. The experience feels new almost every time.

The people in this image are in lockstep with each other on their way to being transported to their destinations. They walk at a slight angle to the tracks; but they could be the tracks themselves. A lyric I wrote best describes for me what is going on here:

Son of a son of a son of a farmer.
I've watched the clock come to dominate my life
and each morning, like Jonah, I climb into the whale.
Its power transforms me for better or worse.

3. Pedestrians never have the right-of-way at the corner of Michigan and Randolph in Chicago, where this street scene was photographed (from the second-floor Civil War museum room in the Chicago Public Library Cultural Center). I wanted to look down on the intersection the same way a spectator in the stands at a stadium looks down to see the pattern of movement of the players on the field.

The idea behind this photograph is that football is based not on the touchdown—that's a further goal—and not on the forward pass—that's an embellishment—but on crossing a ten-yard zone without getting knocked down—much like a pedestrian crossing a busy street. The action in football is staccato, stop and go, like a traffic light; the players' movements between the sidelines and the yard lines are variable. A runner can slant from any place along the line of scrimmage to any place along the forward yard lines—just as a pedestrian crossing a street can veer off at an angle to avoid walking into or being hit by a car. Reaching the other curb means that the immediate goal has been met, but because the streets represent danger zones that must be crossed again and again as people make their way through life, the whole scene is repeated at the next corner.

4. This picture combines a photograph of the head of a Greek statue and a relief of a Greek garden scene. I wanted to get the effect of this person dreaming about, or remembering, the culture in which he had lived. I chose this particular relief because I thought that structurally it would fit into the face—the small statue along the nose, the leaves on the eyes, and the vases as cheeks, creating a facial structure. At the same time I feared that this analogy might be too literal, that it might be seen as an analogy of form, not as an analogy to inform. But as I worked on the montage, what I feared didn't happen, and what I hoped for did. What I especially like is the fact that the tree branches cross the eyes and give the eyes—and therefore the mind—of this stone head the sense of a person dreaming, reflecting, remembering.

If the image does succeed by evoking the feeling of dreaming about the age in which one lived, then

the picture possibly makes it easier for viewers to reminisce about the passing of their own age or of any time now gone. This image therefore may help to build a sensitivity to the human predicament, and a sensitivity to the passage of time in general.

5. As in the Greek relief face, I feared that the analogy between a tree limb and a human limb would be taken literally. In many fairy tales, for example, there are trees that live, that look like people. This analogy is so common that I was reluctant to restate it as the theme for this montage. I felt, however, that this tree had so many anthropo-morphic qualities, its sense of face, of shoulder, of back, legs, knees, and thigh, and the fact of its movement, its roots shifting over the rock, in the same direction as its face and body project, that I had to use it. Not only had it broken loose, but it had broken loose in a direction. A chthonic force taking a slow, dim, yet slightly perceived direction across the landscape. The lacing of the arm to the limb and the reaching, feeling gesture of the hand complete the concept of this force moving ahead, feeling its way very cautiously, very uncertainly, almost unconscious of what is ahead. I see it as a metaphor for culture, another type of chthonic force that I can almost picture feeling its way through time.

6. This montage has a quality that is somewhat different from the others in that it looks like it could be a real place, a channel where people go to swim. The idea originally was to show a crowded beach with people looking across a small stream or shrunken body of water to another crowded beach with people looking back at them. The absurdity is the small amount of water that divides them. One might see this as a shrinking of resources in relation-ship to the population, or the smallness of what divides people, or the scaling down of the space and time of the real, large divisions that separate people even as these divisions cause them to come into contact before—or to a greater degree than—they are ready to do so.

Another aspect of this picture is that the life-guard on the chair at the left carries on the tradi-tional role of a lifeguard who must survey a large body of water. He has not altered his role to fit his more substantial relationship to the immediate situation. He should be standing in knee-deep water, or at least at the edge of the water, where he would be more functional both in the sense of his vision

and his immediacy to the crowd. But he has not done that. The hero is out of touch.

7. We live in the shadow. But the shadow of what?

8. I think that the intrigue of this picture, the idea I had when I composed it, is that as one rides in a plane and looks out over the expanse of cloud forms, one has a feeling that the clouds are themselves a landscape and could be walked in. There is so much space, so many fascinating formations. I long to be there, or to see someone else wandering there.

9. I prefer to remain silent about this image.

10. The statue is nineteenth-century neoclassical; the girl, a passerby in a parade who wasn't roused and didn't know that her picture was being taken. It would appear in a very considered way that the look of the girl and that of the statue have a good deal in common, and because they seem to blend together so well the viewer might jump to the conclusion that the two are similar and were shot in a studio. But the fact of the matter is that, except for the angle from which each is shot, the girl and the statue are so entirely different it's almost unimaginable that in combination they produce this particular facial expression.

Let me describe the statue. It has smooth eyes, and its hair is drawn back in a tightly knotted fashion, emphasizing the hardness and smoothness of the stone. It has an austere yet vacant look. The girl's head and face lend a softness to the statue; they add life to it. The lips of the statue suggest a very quiet, slight movement, and one might suspect that the girl's mouth looked like this, too. The fact is, the girl had an almost angry look on her face; she was either shouting at or yelling to someone.

I mention this because I find it of interest that parts of two or more disparate images can be brought together in a considered and potent way to form a third image that looks so completely unlike either of the two and has the potential for forming an expres-sion or conveying a state of mind. I was—and still am—very leery about combining two or more human faces or a human face with a statue face or a statue body: it's an easy image to corrupt, by use of the grotesque, bizarre, or novel, for its own purpose and without true concern for quality of thought and subject. It can lend itself to form without content, yet seem to have content because of the nature of the face itself.

I believe the combination of stone and flesh in the image I've created suggests a melding of the mortal and the immortal. The girl's eyes and the nearly quiet lips seem to be saying, "I know you. I've always known you. I have been for all ages. You may ask me anything, though I may not always answer." It's that force of the muse that sees generations and ages of happenings and understands what is past and what is meant to be and, if it so chooses, can tell mortals what has been seen and what is being seen. I believe this is the effect of the image on many people, but I know, too, that some people are left with an uneasy feeling because they find the image unsettling.

11. Some individuals I have encountered feel that this picture represents optimism. Among other things, they assume that the person is moving forward and will probably reach the escalator on the right and rise up. Others see the theme of decision making. We are reminded that at certain times in life we must deal very intensely with large decisions, while for most of our lives we are constantly faced with smaller decisions.

Still others see this individual's journey as endless or repetitive: a travel through bleak surroundings toward an uncertain future—not the journey one would choose to make, or the one expected. Somewhere along the line we forget to stop and smell the roses. Furthermore, there is no guarantee that the escalator on the right is going up, and even if it is, at the top may be another escalator and another choice, a continuation of the system.

As for my choice of the two key elements in this montage, the water represents such circumstances of natural life as health, feeling, relationships, our tendencies of mind. Its roll and rhythm have little to do (at least apparently) with the way we would like things to be. At best, we can try to adapt to it, or to prepare for its continuous changes. The escalator stands for human systems that also have their own cadence, changing circumstances, and are barely, if at all, within our control. We are borne along with it. Thus, both parts of the image have a rhythm and movement of their own, and only in some limited way is the individual able to navigate these two vacillating forces.

I believe that the image has a positive and therapeutic quality. On further reflection, usually later in time, the viewer often realizes that the first instinct—which is to say "That's me" or "That's just how I feel"—is replaced by the realization that I was not looking into any one person's mind but made this montage for everyone, each with his or her own share of worries, anxieties, and dim wonder of it all.

A lyric I wrote isn't meant to define this image but to speak to it and at the same time to introduce a truism of human nature:

I'm a pilgrim on the edge,
on the edge of my perception.
We are travelers at the edge,
we are always at the edge of our perceptions.

12. An expressway with overpass and twin gas stations echoes the shape of a stringed instrument. Headlights move down and around the instrument like cascading musical notes. Why can't I make out the song? I can't imagine the edge of sound or space, nor can I conceive of it never reaching an edge. The language that enables us to articulate our thoughts cannot fathom space. Perhaps we're only hearing one instrument in the orchestra.

13. I refer the reader to William Butler Yeats's "The Second Coming."

14. This picture is my most baroque, in the way it fills the frame with imagery and in its nonlinear thrust. I see its pull as a desire for the spirit to wrench itself free from matter. Out of the stone of the earth we build structures that mirror or attempt to represent the feeling that a part of us is skyward bound—alluding to something beyond the life we are living on earth.

By using the form of outstretched bird's wings—a feather and bone structure—to merge with and mirror the skyward motion of the cathedral, I hoped to convey the possibility of a material object rooted to the earth yet soaring, or trying to soar. The struggle between matter and spirit is endless. I also wanted to suggest that the same possibilities and limitations apply to humans. As William Butler Yeats said of the soul, "sick with desire / And fastened to a dying animal / It knows not what it is."

Another element in the picture is the river that winds through the ravine. This snakelike image can be seen as the bird's elongated tail, and this, along with one other reptilian perception, twists us around one last time and affirms that we can never know the nature of the spirit as long as we are encased in matter.

15. The mythological centaur, half horse and half human, speaks to the wondrous physicality of the

human race: speed, movement, physical power, and beauty connected to intelligence and its expressive possibilities. In this image, the human form, the conscious and noble part of ourselves, is not whole but is torn, is pushing and tugging and struggling within and against itself. Is this an attempt to redefine humanity? Is it an attempt to move to a new age? Or does the image represent each individual in and for all times?

16. I don't believe that any comment I might make about this image would add to the viewer's own feelings.

17. Since its construction began and long after its completion, I have walked many times past the Amoco building in Chicago. One day I looked up and was struck by the structural similarity between this building and a Greek pillar. By that I mean that the height-to-width relationship of the building and a classical column are the same. The vertical rows of windows, though in lower relative relief than the flutes of a column, echo the sense of fluting; in fact, the rows of windows are in a two-to-one (though square-to-round) relationship to the flutes of a column. This perhaps reflects an essential difference between the two cultures from which these objects come.

　　In some classical structures the columns are placed at intervals at the edge to support the roof, making it possible to move around each column and photograph it from different distances and at different angles without the impediment of a building façade. Luckily, I found the exact circumstances I needed in Malibu, California, at the Getty Museum, which is partly structured like a Roman villa.

　　One of the more difficult tasks in merging the two images involved the need for a smooth transition from the building to the column, and that involved maintaining the illusion of continuity between the windows and the fluting. The problem, of course, was that there were more vertical rows of windows than there were flutes on the pillar.

　　In general, when I'm working on a particular idea I'm looking for an interesting similarity or an analogy in shape and structure, but mostly for an analogy in concept or function. This picture has both elements: shape is as obvious and as striking as could be, once you stop looking at the building as rectangular; and function is easily understood because of the commonly used phrase "pillar of society." Thus, the urban monolith echoes the

column as part of the larger order, one of the pillars that maintains a society, just as law, belief, education, and so on, are pillars of a nation, a culture, or any complex social structure.

18. The windows of a house at dusk—or is it dawn?—appear to be, or at least look like, the windows of a commuter train. Through them we can see several people sitting, reading. Are they at home? Has the behavior or mood of the repetitive ride taken hold? Or is it that their "home" moves with them? Our lives are divided into separate sections, but do any of us know how long we will persist in this stage, part nomad and part farmer? As Michael Bonesteel so aptly put it in a review of a show in which this image was exhibited: "In this scene, the passengers who normally would view the scene as they whiz by are instead part of the scene."

19. The industrial segment, standing for industry itself, takes in and lets out more than might be imagined. Beyond that a large system is created the nature of which is less objective, less definable than production itself.

20. The sculptor Lorado Taft graduated in 1883 from the University of Illinois and practiced his art in Chicago. His *Fountain of Time* is located on the western edge of the Midway at the University of Chicago, not far from where his studio was. I imposed a major portion of this sculpture onto the upper part of a row of office buildings, so that the buildings would honeycomb into the inner reaches of the statuary. I tried to capture something of the childhood fascination with spaces. As adults, we rarely hope for such possibilities; our predictable geometric buildings (or something) have taken that from us. The effort in postmodern architecture to change that is an effort against great odds, on the one hand, and mistaken or compromised conceptions, on the other.

　　Another thought that comes to mind when viewing this image, and one that I take seriously, involves all those offices, all those windows. What goes on in and behind them? I do know that these structures are filled with people working, socializing, being tired, being happy, looking forward to the weekend, hoping for a promotion or a raise, fearing termination, competing and cooperating with each other, forming friendships, making enemies, joining forces. I know that their personal concerns—their worries, their hopes, their loves—are not left at

home. Their offices and desks, cluttered with the trappings of the workday, are adorned with personal items, with pictures of their spouses, their children, their lovers, their pets. The need for self-expression leads them to explode from their working environment with the cry, "We are human."

21. In this image, the shadows falling down from the pews during an April-May sun onto the aisle/ street serve two purposes. First, they reinforce the phenomenon of the interchangeability of the design from microcosm to macrocosm, with the geometrics of both systems fitting together, in fact echoing each other. The pews alone would not have served as well as the pews with their shadows to bring to mind the size and row and sense of the buildings that line this street filled with cars and people. Second, the shadows serve to help the street fit naturally into the aisle, almost as if it were sewn or zippered into the aisle instead of just sliced in. This translocation of imagery emphasizes the extreme degree to which we are operating in a geometric, linear, rectangular pattern of existence in the systems and environment we've built around us. What else is there or could there be? I believe it was Oswald Spengler who said, "Practical requirements are merely the mask of a profound inward compulsion."

I must mention that I chose this particular shot of the Rockefeller Chapel at the University of Chicago because it was taken before the banners were removed and because the biblical quotation on the banner seen here relates to the other idea I had about this picture. The banner recites the biblical exhortation "Go therefore and make disciples of all nations, baptizing them in the name of the Father and the Son and the Holy Spirit." In retrospect, this proselytizing tendency has so much to do with cultural tendencies and characteristics, and the cars are a link here between the movement to go forth and the system that is taken forth.

22. This image is reductive in the sense that I have chosen only one angle from which to shoot this Henry Moore sculpture, the shape of which changes according to the angle from which it is viewed. The shape we see here is that of a human head, yet the exterior surface gives way to an inward probing. The smooth skull or brain shows a glow of light. The question is, is this light originating from the outside, as in the Promethean myth, or from within?

23. This image is lyrical, a piece where the eye of

the viewer can peruse, wander back and forth, taking interest in the details, in areas where the tree trunks meet the floor, in the interweaving of the branches, in the clustered arrangement of the trees, in the streams of light between the trees. The foreground-to-background shift of the trees is accentuated by the way the small branches caress some of the larger limbs like musical notes creating rhythm within the landscape. Part of what I had in mind is the unification of the ordered and the wild. If the trees were simply stuck on the surface of the floor, then the image would say, "Here we have the wild; there we have the ordered." But with the trees growing out of the floor, unity is realized and the picture says, "Order and disorder exist in tandem," pronouncing the belief that the ordered and the wild are related in an integral way.

This unification is also a vague metaphor for the human mind—namely, that it is made up of the ordered and the wild. The rational, thoughtful part of the mind encounters the part that speaks to impulse, desire, obsession, tendency, intuition, the momentary. For any given act, at any given moment, the mind is motivated more by one than by another. In some undefinable way our minds operate as a mixture of the two.

The forest is indoor and outdoor. Individuals look upon real space, but space known in accordance with the particular feeling that a given culture or time induces in its members.

24. This montage is not about a particular building or place. But because of the sweeping angle of this building one can project or imagine the destruction, the disorder, the nonfunctional sweep through the interior. The possible interpretations are many: outward appearance versus inner reality; the stability of what can be viewed versus the perception of what is not as easily viewed; the act of being taken in by a paper tiger . . .

25. I wanted to show a man and a woman enraptured by each other, each so tenderly and completely absorbed in the other that they are transported, momentarily at least, from their surroundings.

26. The angular top of this building, the way it does not quite come together in front but reveals a slightly recessed open space, the height-to-width relationship, the striping—all reminded me of an abstracted pharaoh. Perhaps I should have worked with a pharaoh other than King Tut—perhaps a

lesser-known pharaoh would have permitted the relationship to speak louder and the viewer would be more inclined to focus on the structure itself. But the Tut head was so beautiful that I succumbed to temptation and used it. Also, the striping of the Tut piece matched so closely the striping of the building.

27. The temporal versus the intemporal.

28. As the controversy over installing lights at Wrigley Field entered its third year, I thought of a way to memorialize this phase of American and Chicago baseball history. Creating an image that looked realistic would have meant taking sides, and if it turned out that the Cubs would play night games at home, then my image would be only a parody of the future. Thus, I decided to make an image of a game taking place during what appeared to be night, but under outrageous and impossible conditions.

The game photo I finally decided to use is from a day game played in 1987, roughly a year before the first night game at Wrigley. I chemically darkened the image, removing the daytime top and slipping in an actual, though altered, night skyline. Numerous other details were inserted or deleted for effect. Clearly the most essential addition was the apparent source of light—flashlights held by the fans—which gives the image its qualities of humor, intrigue, and the beauty of a match-lighting event. In terms of the composition and interest, I wanted viewers to be close enough to the infield to feel that they were actually watching a play in progress, yet I wanted to capture enough of the fans in the stands to give the effect of human activity and implied motion all around.

29. A cowcatcher doesn't catch, it pushes. Its method is more subtle than any cow might suppose.

30. My goal was to create an image that is beguiling and peaceful. The picture is enhanced by the railing and pillars that surround the stone floor; without them the picture would be incomplete. I feel that the railing and pillars act as the bank of this Renaissance pond, this classic moment. The swan is in its proper environment and space.

31. I often refer to this montage as "Easy Grace." "Going through the motions" is one assessment of contemporary religious behavior. Here, the escalator stands for the effortlessness of a trip to the altar above; a sign at the bottom might read: "Step on and you will be close to God."

The other idea that guided me involves shopping, or obtaining some material object, in an attempt to relieve anxiety, stress, or unhappiness. Hence, I used a pair of escalators from a shopping center. Our modern-day altars may be our indoor malls, where we go when we need to buy something but also where we go to attempt to calm or to fulfill our internal longings and desires.

32. This slightly dragon-shaped cloud appears to be moving, blowing almost on its own force across the sky. The air conditioners further the sense of propulsion, of energy. Although a metal mechanical construction, they are analogous (in terms of function) to the clouds and with them form a unified whole. I tried to give this phenomenon some degree of visualization of the Oriental concept of Ch'i. While this is not the forum to introduce a discussion of that concept, I will say that Ch'i can be felt as a vital rhythmic force whose presence is signified in the arrangement and protrusion of forces from the surface, giving feeling to energy and stirring all matter to life, like breath and weather.

33. The structural compatibility of the two arches coming together with the central stone between them seemed to me to be so much like the central part of a human skull, its ability to support weight beyond question. I thought I could bring out the anthropomorphic qualities of these arches, which are located in the Rockefeller Chapel at the University of Chicago, by merging them with a picture of a forehead. The wildness of the hair matches the wildness of the vegetation, suggesting a swirl of matter, not hard or ordered.

I included the pews not only because they allude to the lower part of the face but because their order contradicts the disorder of the hair and helps to symbolize the mind, the force of thoughts and intentions that govern a person's actions. I believe this picture represents the dichotomy between Apollinian thought and Dionysian thought—the former being life in terms of order, consciousness, discipline, rationalism; and the latter, a disposition of life as wild, chaotic, unconscious, and undisciplined emotionalism. The pews also function in a stony, ironic way because it is there, age after age, that people have sat and received instructions from the pulpit on the phenomenon of the ordered versus the unordered mind and behavior.

34. The idea behind the picture was that normal space—if you can call a bus station normal space—can be given a physical characteristic that is more like an abstraction, a displacement, or a confused mood or feeling. The emotional terrain that exists in a bus station is complemented here by the disturbance these people encounter. Yet in the image the people continue to walk through an altered space as if it were normal; the altered reality does not seem to affect their preexistent pattern of how to behave. For me, this picture is a metaphor for the lack of reorientation of act and thought when confronted with a new environment, or a new reality.

The people in this montage were all in the bus station at the time I took the photograph; the rocks had been photographed along Lake Michigan and I needed to enlarge them about 400 percent in relation to the bus station. Since I had a pretty good idea how large the rocks were going to be and where they were going to be, I waited in the bus station and watched the arrangement of people as they passed through the space. I visualized when and where around the unseen rocks the voyagers would arrange themselves. Then I took the shot. I spent more time in the bus station than I thought I would.

35. This image is based on another Lorado Taft sculpture, *Fountain of the Great Lakes,* which is outside the Art Institute in Chicago, set back from Michigan Avenue. The five women, each holding a large half shell, are a metaphor for the five great lakes; like the lakes, each woman is pouring the water from her shell into the shell below. The base of the actual sculpture is a rectangular pool, into which the woman at the bottom of the chain pours the water from her shell. I can't help but think that if Taft could have done it, the statue would have been set on a shoreline, somewhat like it is shown here, with water pouring into the very lowest half shell imaginable—the ocean.

Library of Congress Cataloging-in-Publication Data

Mutter, Scott, 1944–
 Surrational images : photomontages / by Scott Mutter;
 foreword by Martin Krause.
 p. cm.
 ISBN 0-252-01935-0
 1. Photomontage. I. Title.
 TR685.M87 1992 92-9763
 CIP

Edited by Theresa L. Sears
Designed by Edward King
Composed in Adobe Stone Serif by Hillside Studio
Scanning and prepress by Andromeda/Flying Color Graphics
Printed and bound by Kingsport Press/Arcata Graphics